ABCDuane

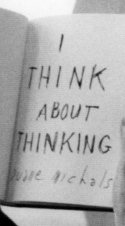

ABCD*uane*

A Duane Michals Primer

THE MONACELLI PRESS

in cooperation with Carnegie Museum of Art, Pittsburgh

WITH GREAT GRATITUDE TO:

Josiah Cuneo, Ben Diep, Michael Amaerusa, Ray Adams, Bridget Moore,

Lily Zhou, Andrea Cerbie, Priscilla Caldwell, Linda Benedict-Jones, Amanda Zehnder,

Katie Reilly, Laurel Mitchell, Brad Pitt, John Painter, J'Kistine and Brian Alspauch,

Jonas Cuénin, Star Black, Maya Piergies, Super grafiker Mark Melnick, Christopher Lyon,

Alan Rapp, Anthony Troncale, Michael Vagnetti, Madeleine Compagnon,

Robert, Matt, Fred, and my personal savior Jesus.

———

LIBRARY OF CONGRESS CATALOGING-IN-PUBLICATION DATA

Michals, Duane.
ABCDuane : a Duane Michals primer / Duane Michals.
pages cm
ISBN 978-1-58093-405-3 (hardback)
1. Photography, Artistic. 2. Michals, Duane. 3. Photographers—United States—Biography. I. Title.
TR655.M53 2014
770.92--dc23 2014021843

Page 2: Duane Michals, *I Think About Thinking*, 2000

Design by Mark Melnick

Printed in China

1 3 5 7 9 10 8 6 4 2
First Edition

www.monacellipress.com

Contents

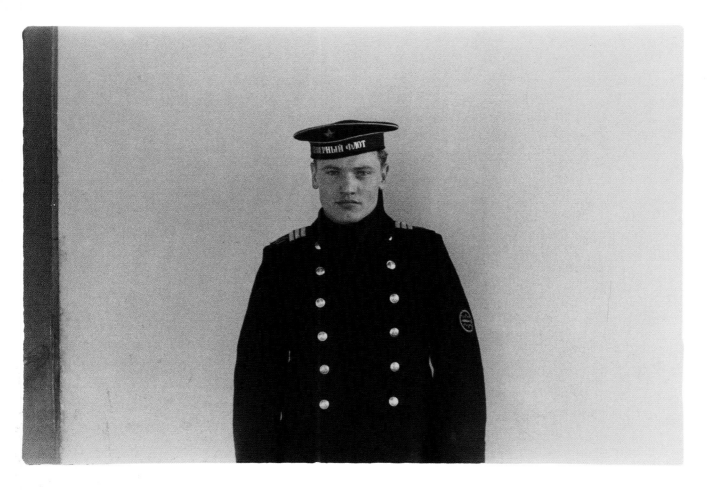

Sailor in Minsk, 1958

———

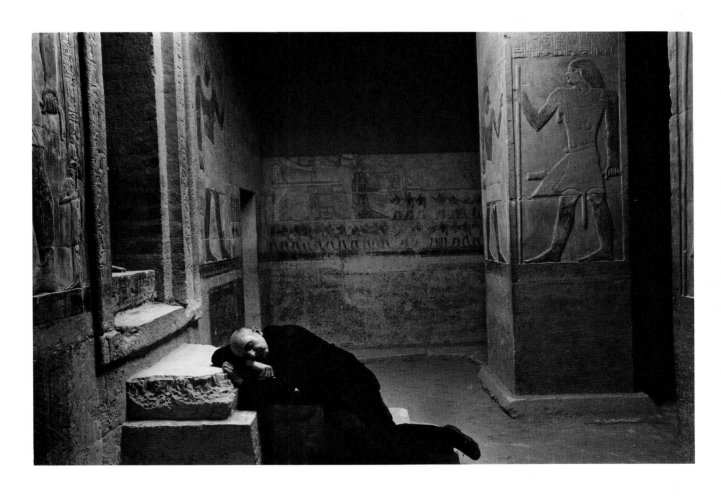

Self-portrait Asleep in the Tomb of Mereruka at Sakkara, 1978

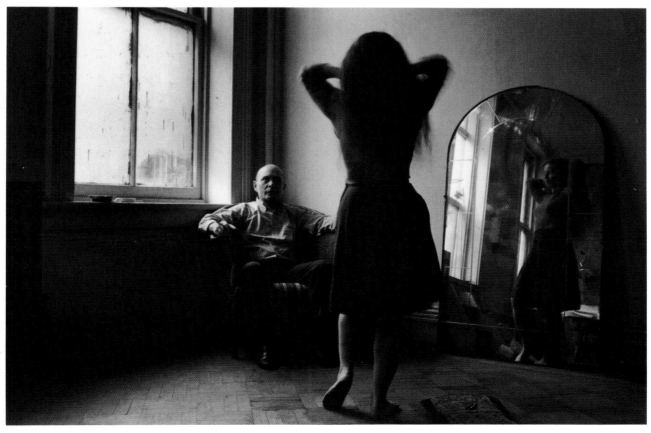

Life Is a Story

—

Foundrom once upon a time to they lived happily ever after and may he rest in peace: life is a story. It starts with a lullaby and ends with a dirge. We are hero and author; what lies, what drama, what foolish dreams we imagine. Don't be shy, it's all goodbyes. We grasp and our palms are empty, nothing.

Where, why, how, and when are the questions I ask and then answer. I remember an old lady crying, sitting on a derelict sofa surrounded by the debris of her life, on the sidewalk, evicted. I was in the third grade, on my way home from school for lunch, when I saw this sad tableau and lost my appetite. I wonder why I still remember this itinerant memory culled from my life's script. Every square inch of our personal history is redolent with such tiny fragments.

Upon close examination, our story is one long adventure, as we whistle in the dark, afraid of the boogeyman. To be alive is to be skating on thin ice with the possibility of falling falling falling. Taking photographs and writing is my way of saying I was here, I saw this, I felt this, I heard this. It happened.

With every entry in this book I am sharing with you the whims and tattered thoughts I can still recall, illustrated mostly with unpublished photographs of mine, and also reproductions of prints and drawings that I have donated to Carnegie Museum of Art. It pleases me that one day I will see this work, which has given me so much pleasure, on the walls of a museum.

OPPOSITE & FOLLOWING SPREAD: *For Balthus,* 1965

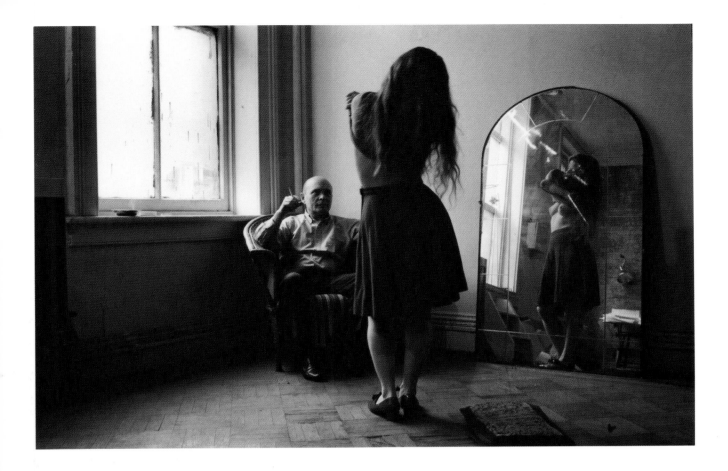
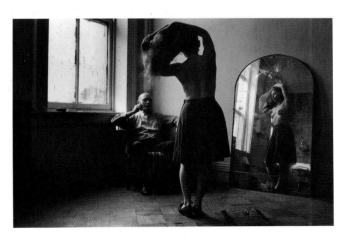
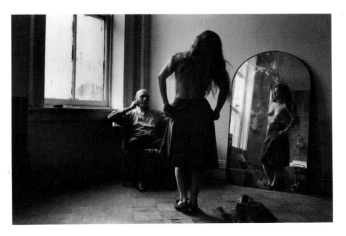

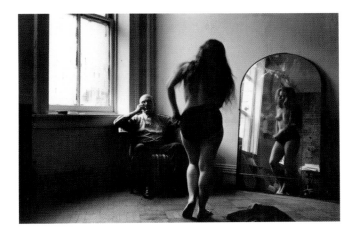
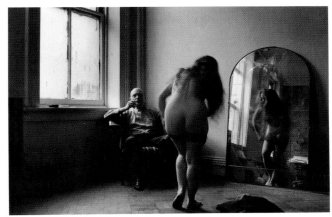
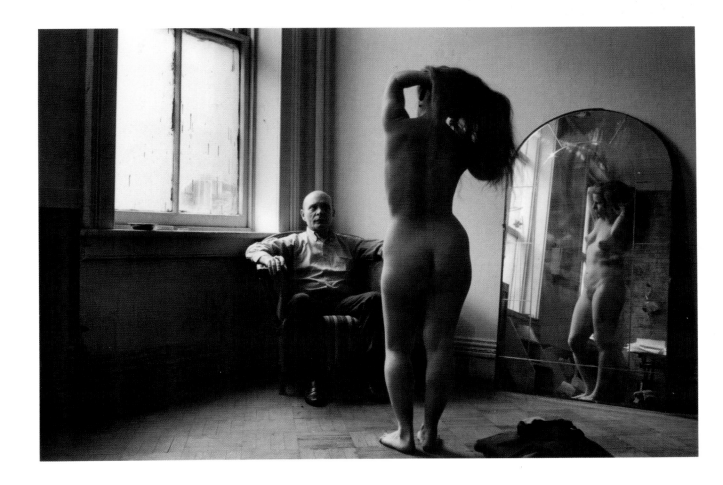

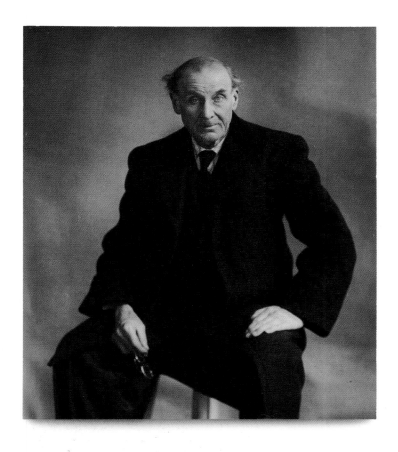

Atget

A stooped old man carrying a large tripod and camera moves slowly down the gray rue du Bac, looking for a particular intersection in the grisâtre mist of early-morning Paris. The year is 1902. A horse drawing a wagon clomps past him down the street and vanishes into the grayness as the echoes disappear with it. The old man notices a mannequin in the window and stops to consider the view. He slowly sets up his camera and disappears under the black cloth, he focuses on the reflections, and then, pleased with the picture he has taken, he moves on and disappears into the fog himself. The photograph is in a book, published in Prague, which I discovered 60 years later, and thus I met the photographer Eugène Atget.

It was a fortuitous event for me. I became so enchanted by the intimacy of the rooms and streets and people he photographed that I found myself looking at twentieth-century New York in the early morning through his nineteenth-century eyes. Everywhere seemed a stage set. I would awaken early on Sunday mornings and wander around New York with my camera, peering into shop windows and down culs-de-sac with a bemused Atget looking over my shoulder.

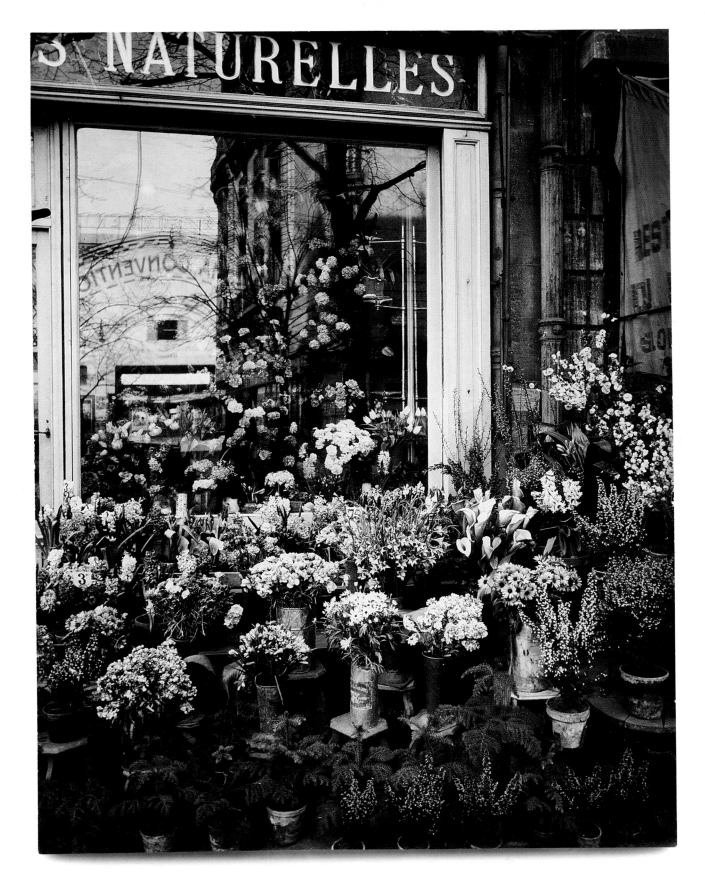

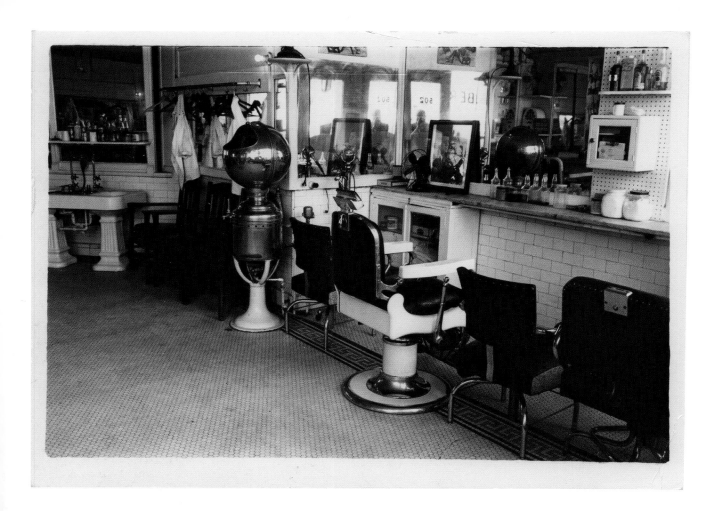

I once photographed an empty barbershop through its windows. Over the arm of the barber chair was the white cloth the barber used to drape over his customers' shoulders. On a hanger next to the mirror was his white jacket, his barber costume. Suddenly I saw the room as the scene where the barber starred as the hero in his private theater. This moment was the Rosetta Stone that opened the door of my mind to staging my own photographic dramas. Everything was theater; even the most ordinary event was an act in the drama of my little life. I had become Atget's apprentice.

That was an evolutionary year for me. I also was looking at Balthus's magnificent painting *The Street* (1933) at the Museum of Modern Art, with its artificially posed actors treading like somnambulists across a dream street. The alchemy of combining Atget with Balthus liberated my imagination. Atget was not a destination for me but a point of departure. My Atget adventure was a five-finger exercise. I was practicing something but I didn't know what that something would be. What now?

PAGES 14–17:
from the series *Empty New York*,
1964

ABOVE: **BALTHUS**,
Study for *The
Mediterranean Cat*,
1949

Balthus, Balthasar, Baltusz Klossowski de Rola: the Count de Rola was the last of the grand painters of the twentieth century to survive. The perverse innocence of his paintings of young girls might have him arrested today, although he pretended to not comprehend why they might be seen as perverse. His was a cunning, transparent pretense of naiveté not worthy of such a sophisticate. The elegant drawings of the "King of the Cats," the pure beauty of his brush strokes, and his understanding of color were superb. He just painted.

In 2000, a year before his death, I found myself on a Sunday night in Geneva, Switzerland, nervously waiting to hear if on Monday my appointment to photograph Balthus at his last home, the Grand Chalet in Rossinière, would be honored. The maestro was notorious for making an appointment and then pretending that he had not, disappointing journalists who had traveled miles to see him. With Tana Matisse running interference, I had managed, after many years of trying, to schedule this

visit. I was pleased when his wife Setsuko informed me that indeed he would see me the next day at noon.

I took the single morning train that would deliver me to his doorstep. I knocked on the door promptly at noon, only to be told by Setsuko that I should come back at two. I went to the only coffee shop in the village. It seemed prudent that I should arrive earlier than two, given that the last train leaving Rossinière for Geneva was at three, and I did not want to jeopardize my one-hour window of opportunity.

Nervously knocking at the door at 1:45, I felt relieved when I finally met the legendary Count de Rola. There, leaning on the arm of a caregiver, a slight, fragile octogenarian with a still handsome face put forward a wrinkled hand. After a few pleasantries, he inquired in perfect English where my home was. I answered New York. Then he asked, "Have you ever been to New York?"

BALTHUS, Study for *Passage du Commerce-Saint-André*, 1952–54

His assistant said, "Where would you like the Count to sit?" Upon hearing the word sit, Balthus began to sit where no chair existed. His caregiver frantically exclaimed, "Don't sit, don't sit," but the count continued to drop in slow motion. Panicked, I quickly grabbed a chair and slipped it underneath him as a destination for his ass—thus saving me from being known as the Balthus-killer.

A signature pose for the maestro's models was sensually looking at themselves in the mirror. I had put a small hand mirror in my camera bag so that I could duplicate Balthus's pose. After all these years he would face the looking glass himself and see that he had become an old man on the cusp of death. Everything was there in the telltale lines of his face. Setsuko glanced at him quizzically, and that was my portrait of the King of the Cats.

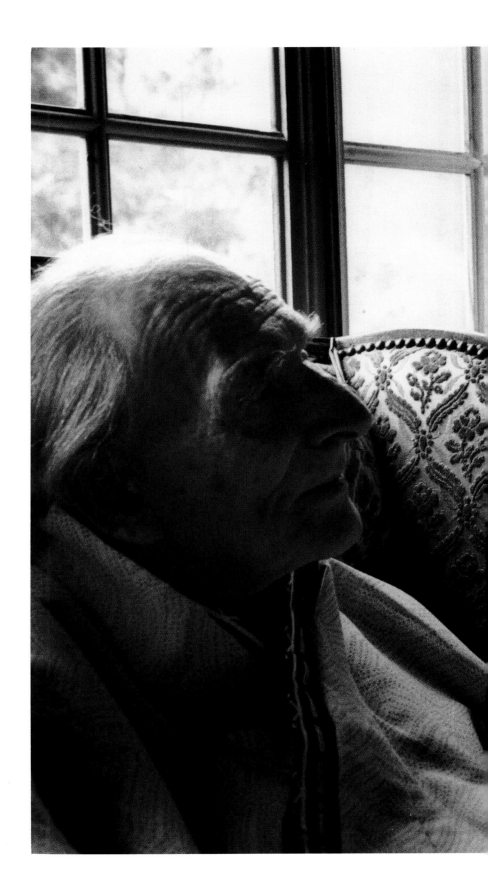

Balthus and Setsuko, 2000

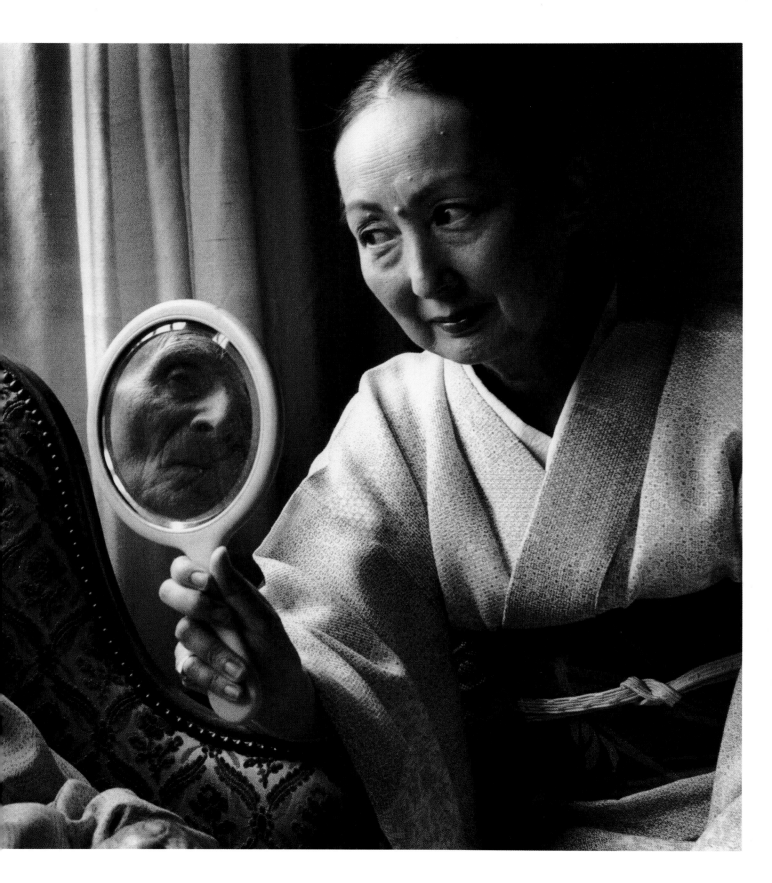

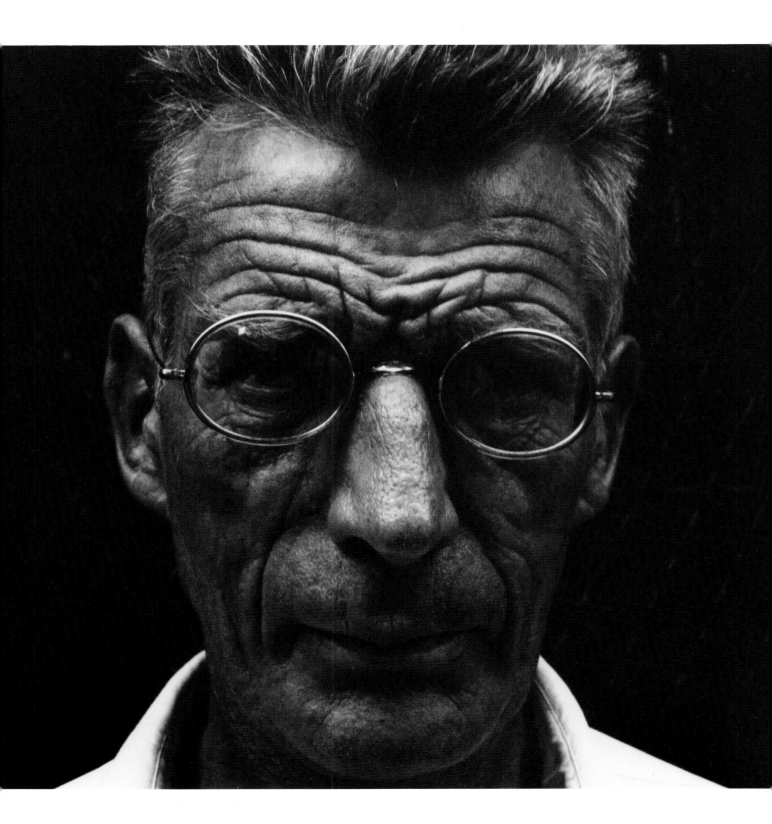

Beckett

Waiting for Beckett:

I went to West 4th Street, between West 10th and Charles Streets, to photograph Samuel Beckett on the set of a film one August afternoon in the 1980s. I waited an hour for him to appear, and another half an hour for him to make himself available. Then I spent another half an hour cajoling him into posing. As I was working with him, he was called away for some reason by the producer, and I waited another twenty minutes for him to return. Then he excused himself to go to the men's room, and I waited another fifteen minutes for him to return. During the shoot I waited for him to say something, but he just sat there and said nothing. I felt he was waiting for something to happen. Then I discovered I ran out of film, and he waited for me as I ran to the film store. When I returned, he was sitting there just as I had left him, waiting.

I spent half an hour with him, and hardly a word was exchanged.

OPPOSITE: *Portrait of Samuel Beckett*, c. mid-1980s

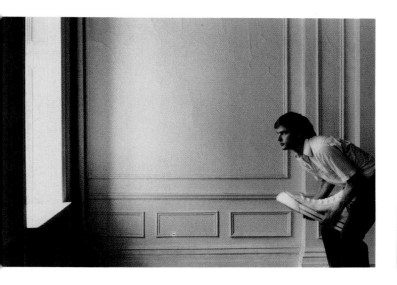
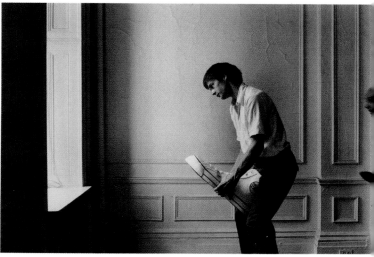

Burlesque

A parking lot on Forbes Street in downtown Pittsburgh was once the location of an old-fashioned burlesque house called The Casino. When we were juniors in high school, my friend Don Henry and I decided that we would go check it out. We needed a cover story. The Knights of Columbus were having a Catholic rally in Forbes Field, and we told our parents that we were going to attend. Liar, liar, pants on fire. We took the trolley downtown, and although we looked like a couple of kids, we managed to slip by the ticket taker, who was reading the *Pittsburgh Sun-Telegraph* and chewing gum. We felt conspicuous, seated there in the midst of the sea of bald-headed men. A young guy with a soiled jacket came down the aisle hawking refreshments, and we ordered Cokes.

The lights dimmed, the orchestra blared an overture of bump and grind thumps. After the fanfare, the curtain opened to reveal a nurse and dentist in a skit called "The Doctor Is In." I remember that the doctor, who reminded me very much of Groucho Marx, approached a terrified patient with a comically oversized hypodermic needle. The nurse was stuffed into a white uniform, and I wondered if she was on the inside of the dress struggling to get out, or outside of the dress struggling to get in. The doctor constantly dropped his plastic gloves, and she would dutifully

PAGES 24–27:
Burlesque, 1979

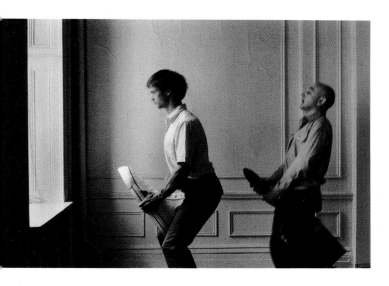

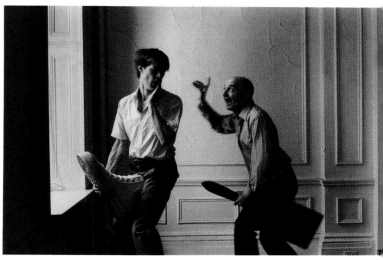

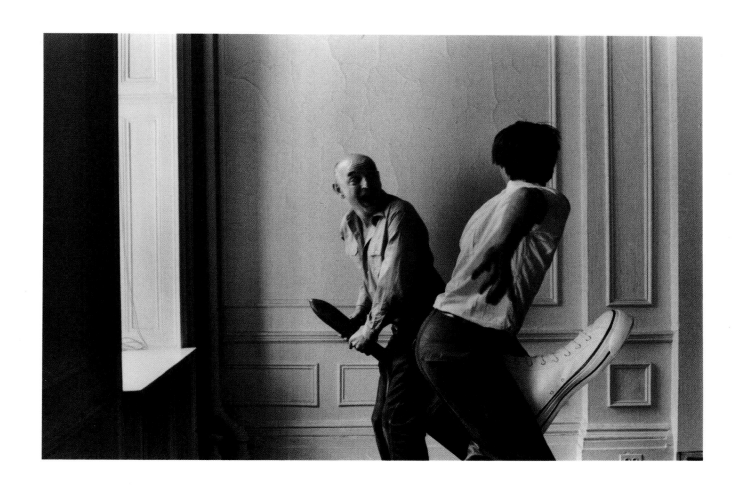

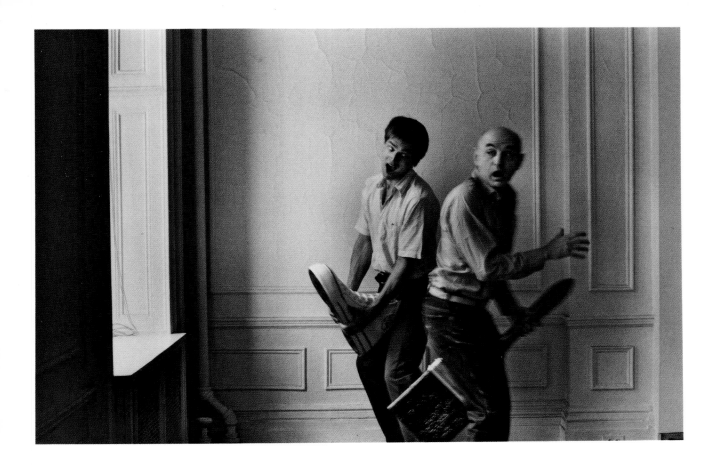

bend over to pick them up, at which point the patient would arise from his chair, with a huge magnifying glass, to examine her derrière. In another tableau the same nurse became a makeup artist, carrying a huge powder puff. When the director in the skit shouted "Make-up!" she would rush forward and slam him in the face, and he would vanish in a huge cloud of powder. There were many exaggeratedly large props used as punch lines for obvious jokes: a large banana, a giant pistol, and an oversize umbrella that was opened and closed rapidly for maximum effect. But the best part was the dancers with the twirling tits, whose tassels were mesmerizing in the stage lights. And of course the traditional "bump it with a trumpet" routine.

After catching the last trolley, we arrived at my house at three AM, to be greeted by my frantic parents. Don's father had been calling as well, worried about his wayward son. The jig was up; we were busted. And although we enjoyed the spectacle and the tawdry atmosphere, we each experienced it in a different way. For most sixteen-year-old boys, a six-pack of jugs alone guaranteed a big-time boner bonus. For me it was all about the feathers on the floozies.

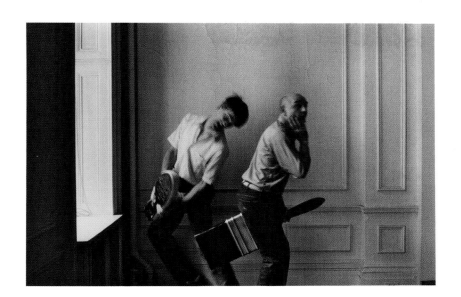

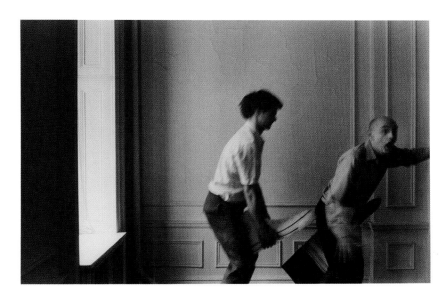

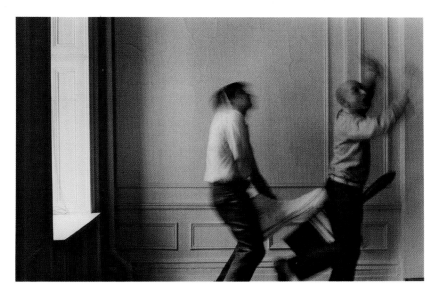

*C*admus

Any survey of American art published in the 1940s would have included Grant Wood, John Steuart Curry, Thomas Hart Benton, and Paul Cadmus. Of the four, Cadmus was the bad boy, having gained notoriety with his painting *The Fleet's In!* (1934), which portrayed sailors on leave carousing with shady ladies in a New York City park. This prompted a complaint from the Secretary of the Navy at the time. Any close examination of Cadmus's work would have revealed that he was gay. This was in the thirties and forties, when that description pegged him as an outsider, even though he was a marvelous painter and draftsman. This subject matter would always make him peripheral in the art world.

When I scanned art books in high school, I was drawn to Cadmus's work without understanding why I found it so alluring. My nascent awareness of being gay was responding to the atmosphere of homoeroticism he created. His painting *Gilding the Acrobats* (1935) particularly caught my attention, not just because of the perfect rendering of anatomy and painterly quality. The depicted touch of the gilder's paintbrush to the acrobat's skin became a surrogate for my hand. My naïve self didn't understand that my encounter with the image was erotic.

As a sophomore at the University of Denver in 1950, I wrote a sophomoric letter of adulation to Cadmus. A few weeks later, as I collected my mail at the dorm, I was stunned to see that he had answered me. It seemed unbelievable that he actually wrote me. After graduating, spending two years in the army and arriving in New York

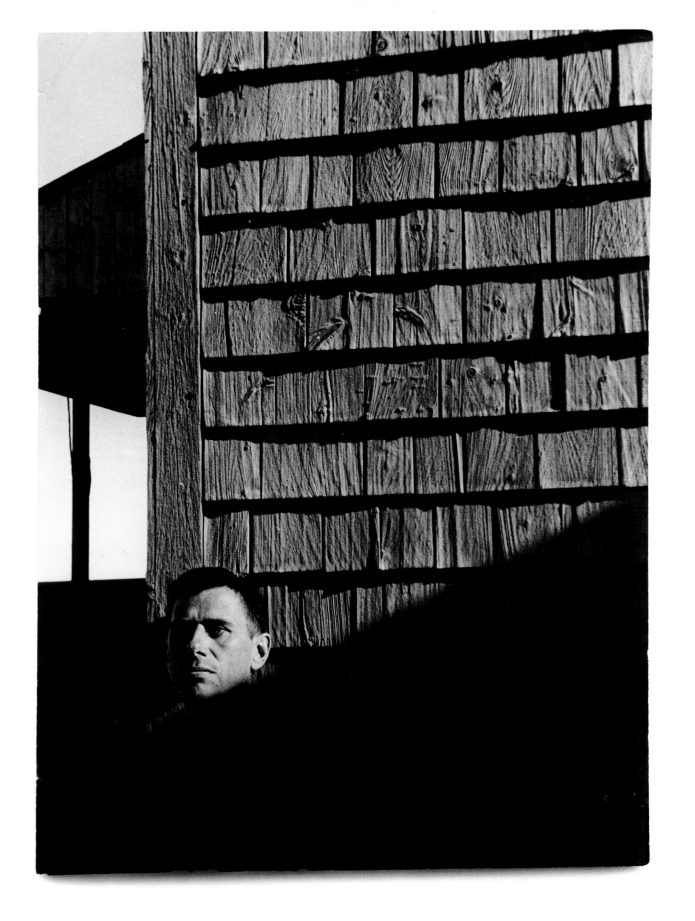

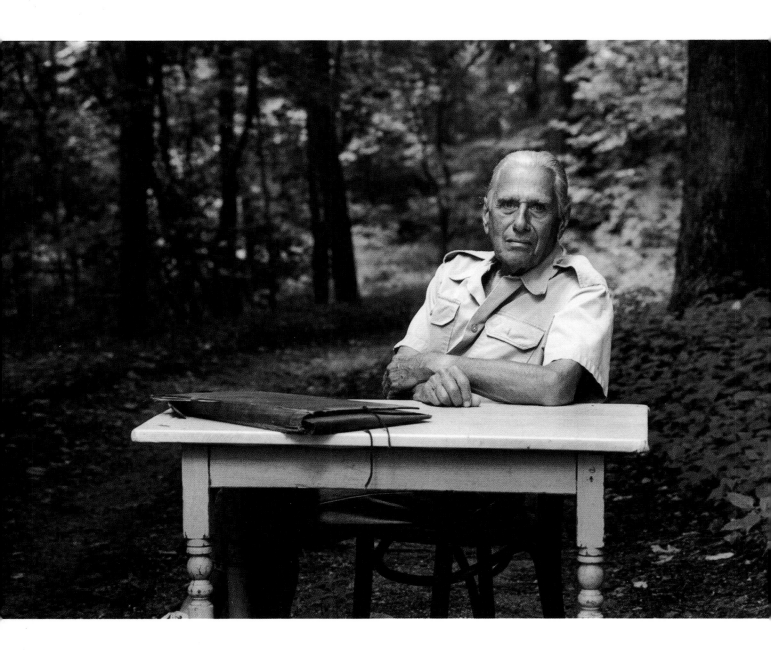

in 1955, I found a wonderful little four-flight walk-up on Charles Street. A visit to the Midtown Gallery on 57th Street provided me with Cadmus's New York address. He lived on St. Luke's Place, which was a few blocks south from my apartment. One breezy Saturday afternoon in October, I wandered to his address, and when I buzzed his doorbell there was no response. "Well," I thought, "I'll just sit here until he comes home." I waited about five minutes, and there he came, walking towards me down the street, carrying bags of groceries. I reminded him of my letter of five years earlier, and of course he had no recollection of it. He invited me to his top floor studio and served Scotch in Venetian blue glasses under a luminous skylight. He was soft-spoken, almost shy, and I think pleased to have a visitor like me. On the easel I saw his current painting, which he shared with me, and I left thrilled.

Decades later, I was photographing the director of the Hudson River Museum and asked what new exhibitions they had on their agenda for the fall. Among them was a Paul Cadmus retrospective. I told him about my Cadmus story, and he invited me to the opening. My great friend Fred and I attended, with growing excitement at the possibility of seeing him again. As I searched the crowd at the gallery, I saw him, looking much older, a handsome patriarch. When I was finally reintroduced, Cadmus of course recalled nothing of our past history. My big surprise was when he told me he'd had lunch the day before with some friends, and they had discussed my work. It is immodest of me to say that he found my photographs as alluring as I had found his paintings when I was a boy.

———

OPPOSITE: *Paul Cadmus*, 1992

Truman Capote was as queer as a three-dollar bill. He was an old-fashioned fairy whose lisping voice, combined with a Southern accent, produced a swishing sound. His wrist was as limp as Quentin Crisp's. Truman instantly became a literary sensation with the publication in 1948 of *Other Voices, Other Rooms*. The portrait of him in a languid pose on the back cover added to his notoriety. Being a genuine talent saved Capote from becoming a novelty item. Soon he became a mascot of the very wealthy and traveled in their social circles. The apex of his ascendency was his famous Black and White Ball of 1966, which brought *tout le monde* to the Plaza Hotel.

After the triumph that year of *In Cold Blood*, Capote's fall from grace was exacerbated with the publication in *Esquire* magazine of a chapter of his work in progress, *Answered Prayers*. Truman imagined himself to be the new Proust and felt that his power as a literary icon gave him the license to write about what he perceived to be the foibles of the moneyed crowd. Society closed ranks and his treachery brought him down. The court jester lived isolated in a cocoon of alcohol. The book was never published. *Sic transit gloria mundi*.

On the day Bobby Kennedy was assassinated, I was photographing Capote with some women in his UN Plaza apartment. I worked with him on many occasions, and we had established a comfortable rapport. I suppose he sensed I wasn't cultivating him as a career move, and he could talk to me freely; we were friends lite. After we finished the photography and the ladies left, Truman asked me to stay and have a drink with him. He was very distraught. Lee Radziwill had phoned him that morning with the tragic news of Bobby's death. He spoke slowly as he sipped his Scotch, and he recalled the last time he had seen Bobby Kennedy. It was on a Sunday morning, a few weeks earlier. Truman had gone out to buy the *New York Times* and saw Bobby standing on the corner, talking to a group of young teenagers. Kennedy spotted Truman and yelled, "Truman, come over here, I want you to talk to these boys." They had been smoking and Bobby was admonishing them about the evils of nicotine. Kennedy continued, "This is Truman, and he would never smoke cigarettes." Truman replied, "Heavens no, I would never put a fag in my mouth." As he reminisced, a faint smile briefly relieved his face of its melancholy.

OPPOSITE:
Truman Capote,
1968

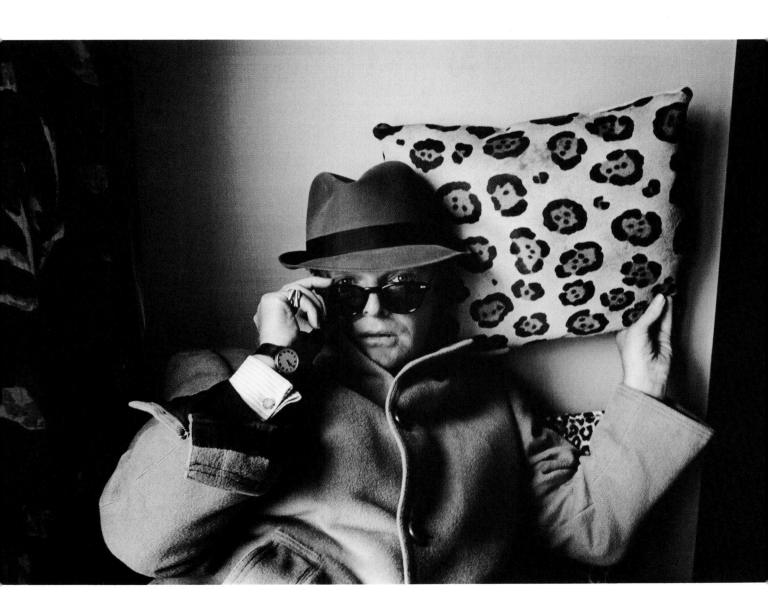

Norman Always Said "No."

Norman always said "No."

He never said yes.

Unless you offered him sweets.

Then he'd repeat.

"Yes, Yes, Yes!"

Children's Stories

"No" to school he'd say.

"No" to anything but play.

"No" to soap.

"No" to beans.

"No" to almost anything.

"No" to naps.

"No" to wearing scarfs and caps.

Norman always fell asleep,

Counting No's instead of sheep.

Then one day,

His mother said that they were going to move away.

When asked if he would like to go,

Instantly he answered "No!"

For much to his distress,

Norman had forgotten how to say

"YES"

Now he sits there all alone,

Saying no,

To no one at home.

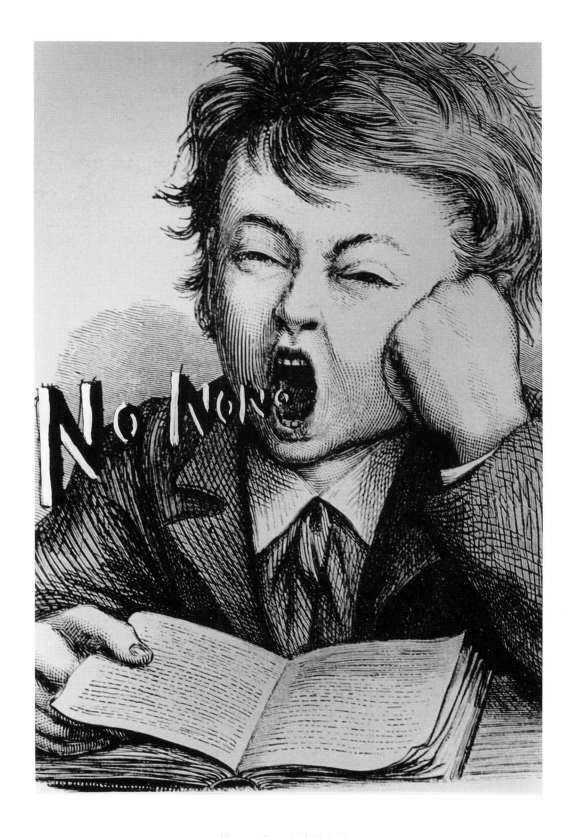

Norman Always Said "No," 1980

Children's Stories

I Wish You'd Go Away

Wally, a six-year-old bad boy, had attitude, but no gratitude. One day at dinner his mother said, "Eat your beets," and then she left the room. Wally hated beets because he didn't like their color. He stared at the maroon beets and in a pique growled, "I wish you'd go away." And they did. The plate was empty. "Oh wow, how did I do that?" He then looked at his glass of milk and said, "I wish you'd go away," and just like that it vanished too. "Wow, wow, how did I do that?" He spotted his mother's cat Petunia in the corner and said, "I wish you'd go away," and zap, the cat was gone. Being full of his magic, Wally began to make the table, the dirty dishes in the sink, the refrigerator, the window curtains, everything disappear.

His mom entered the kitchen and was startled to see it empty, except for Wally. "What have you done? Where's Petunia? Where's the sink?" she cried. Unbeknownst to LITTLE WALLY, he had become a BIG SHOW OFF, and a smart aleck too. He turned to his mother and without any hesitation said, "I wish you'd go away."

As dusk arrived and the room darkened, Wally sat on the floor of the vacant room and began to cry. "Mommy, where are you? I'll eat my beets." And that's how Wally lost his mommy.

OPPOSITE:
I Wish You'd Go Away,
1980

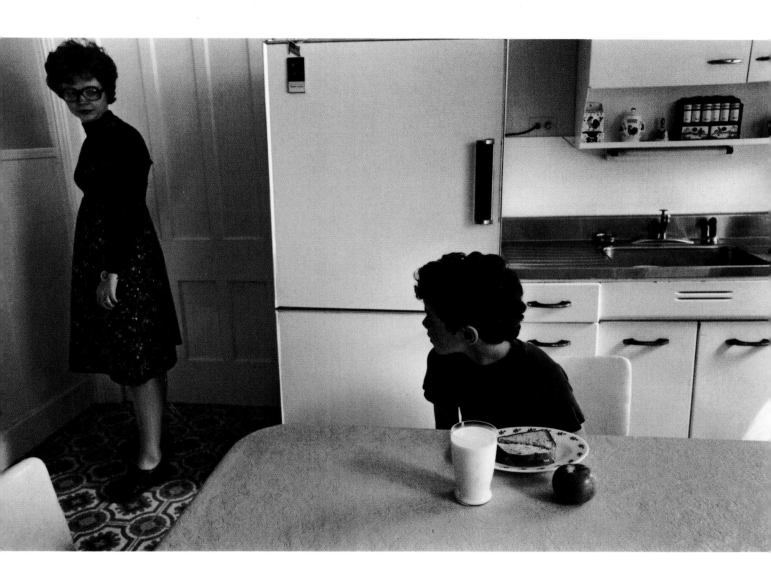

C*ornell*

In a modest working-class house on Utopia Parkway, in Flushing, Queens, lived an alchemist who called himself Joseph Cornell. From ordinary pieces of wood he would fashion a box, fill it with ephemera from old Fourth Avenue bookstore bins and curiosities he had found to create romantic objects of visual poetry. Poetry cannot be tangible; it is a fog that one enters into and becomes lost in. Cornell never traveled, yet his oeuvre is redolent with French hotels ideal for trysts, Russian ballerinas, and parrots echoing dead voices, all the stuff of dreams.

I fell under the spell of the elusive Mr. Cornell's magic illusions, and I was lured to Utopia Parkway, hoping to become the sorcerer's apprentice. A mutual acquaintance instructed me that the price of admission into Cornell's aerie was a box of marzipan-pink too-too sweet bonbons. I was greeted on the first of my many visits by a wizened wizard whose home seemed to have been decorated by the Collyer brothers, those famously compulsive hoarders. The entire house was a treasure trove for a photographer, but I never would lift my camera without inquiring of Mr. Cornell, "Do you find this interesting?" If he said yes, that meant it was OK to photograph. No meant no. Eventually he took me into his basement workshop, where he invented his magic potions. His boxes of collected debris filled the room helter-skelter. He never showed me his magic wand, nor did I want to see it.

In the winter he always wore a fluffy pink angora sweater one might expect to find in a teenage girl's wardrobe. We would often have tea and a conversation. Mr. Cornell had a dangerous ancient gas stove in his cluttered kitchen. As he would light his stove to boil water, I held my breath for fear that the leaky gas would ignite his animated sweater, and we both would be blown to smithereens. Taunting fate, he gesticulated effusively as he reached across the blazing stove for his box of bonbons to share with me. I would decline. I often suggested that this relic of a Tappan stove should be replaced with something more contemporary, perhaps electric. He never replied. Somehow the sight of a flaming Cornell seemed appropriate for a poet's demise.

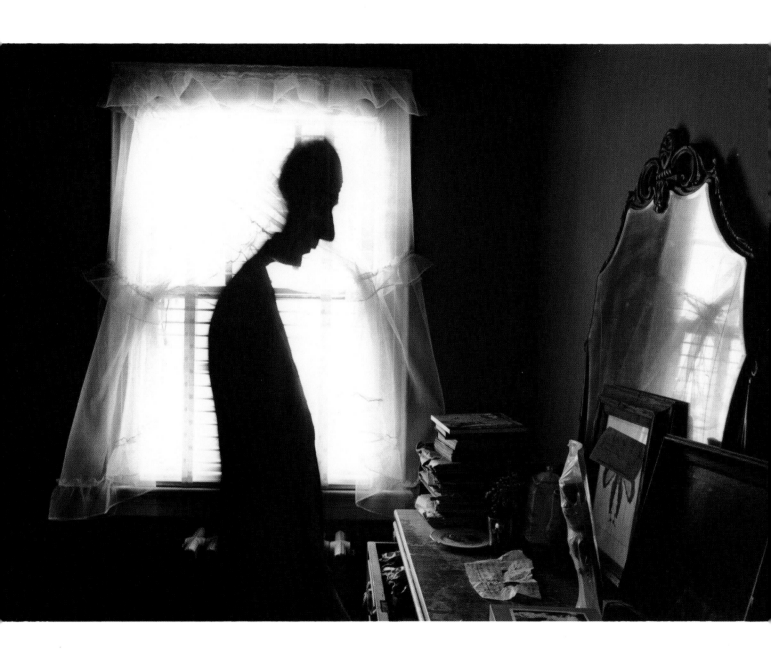

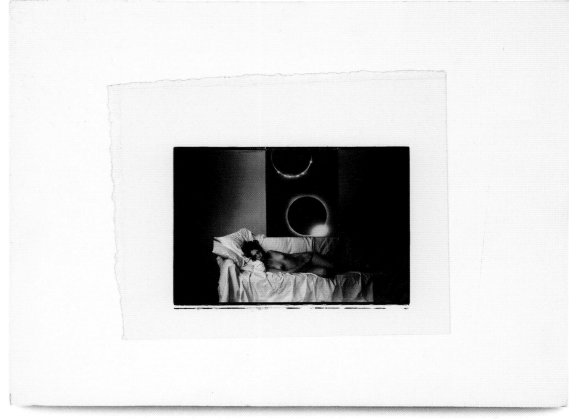

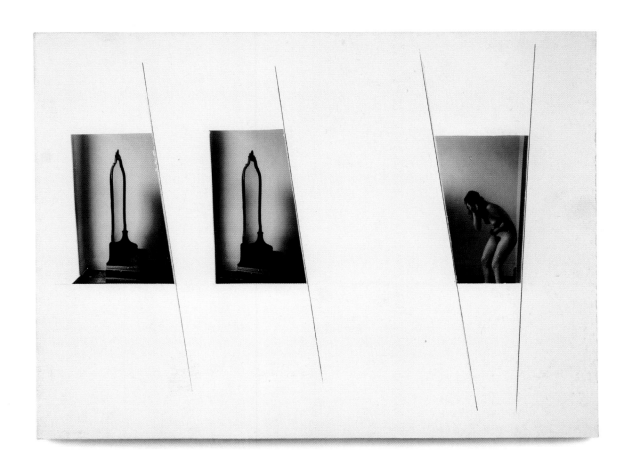

OPPOSITE & ABOVE:
JOSEPH CORNELL,
Untitled (collages incorporating photographs
by Duane Michals), 1971

Cubism

Before Cubism there was no Cubism. After Cubism there was something called Cubism. Cubism sprang full-blown from the heads of Braque and Picasso as a virgin idea. The surprise of Cubism is that its visual vocabulary did not exist in the history of art up until 1909 or so. There were no precedents to guide the viewer to a comfortable destination. Cubism discomforted. It made no sense. It was built on works by Cézanne in which he reduced landscapes to abstract slabs of color. One can trace the disintegration in Cézanne's canvases of the traditional. As he matured, he became more daring, defining a tree, for example, with geometric forms. Building on Cézanne's structure, Picasso and Braque advanced to a place that was the logical destination toward which Cézanne had pointed. In the paintings Picasso made in Horta the transition is obvious. Cubism opened a Pandora's box of invention and a purity that freed Mondrian and Léger, and made possible Duchamp's *Nude Descending a Staircase*.

There's a certain death-defying leap into the future in the body of work both artists created, symbiotically, and to this day its long shadow still disquiets many. In the work, this explosion of experimentation can be seen in introducing lettering and house painter's techniques, and collage incorporating scraps of newspaper, sand to give texture, and faux wallpaper patterns. I respond to Cubism's squiggles, accidents, and an honesty that seems uncontrived. It's very difficult to pinpoint the exact place where I feel this work. I can't analyze my response.

After the historic period of their collaboration, which ended when Braque was called up for military service in 1914, the spent lovers Picasso and Braque separated and embarked on new journeys. They both lit cigarettes and smiled.

OPPOSITE:
GEORGES BRAQUE,
Fox, 1911–12

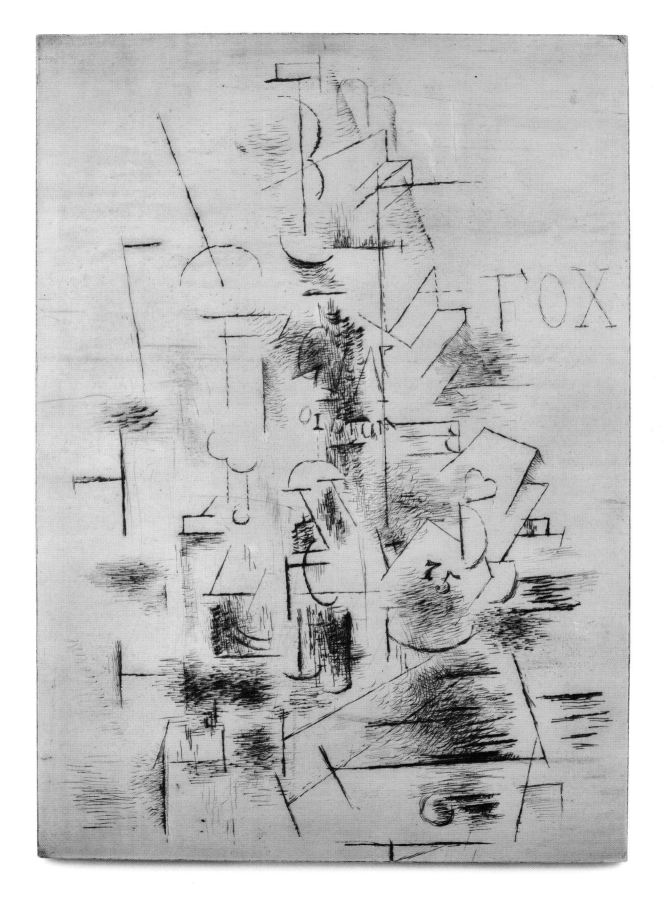

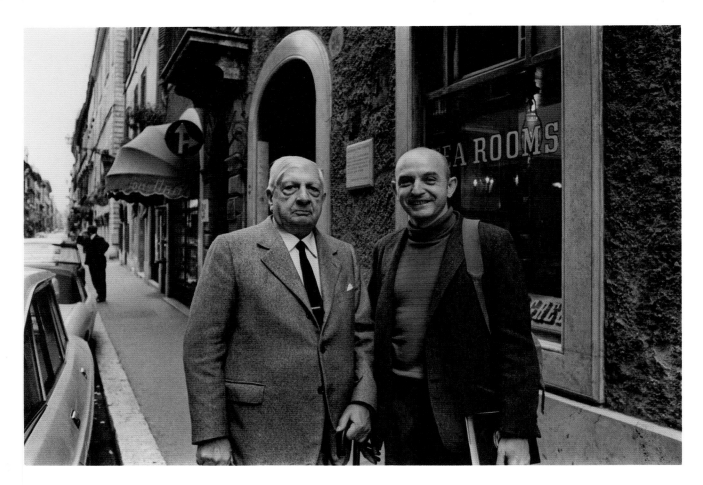

De Chirico

While riding a tram on the Left Bank of Paris, Max Ernst casually glanced out a window and spotted a very peculiar painting displayed in a small gallery. It intrigued him so much that he got off at the next stop and ran back to take a closer look. The painting was *The Song of Love* (1914) by Giorgio de Chirico, in which a huge red rubber surgeon's glove is pinned to a panel beside the marble head of a Greek god. In the background, at the lower left corner, a locomotive is silhouetted, and in the foreground there is a green ball. To the right in sharp perspective is a colonnade and the upper story of a building—all quite contradictory and poetic. De Chirico's paintings all had a disturbing awkwardness, totally illogical, as in Rimbaud's verse, and an aura of shadowy uncertainty. André Breton, the P. T. Barnum of Surrealism, immediately recognized in de Chirico's vocabulary of mannequins, empty Italian plazas, and silent ancient Greek statues the visual equivalent of his verbal Surrealism. Wisely, de Chirico withdrew from

Breton's orbit and maintained his independence. The great period of de Chirico's brilliance lasted from 1909 to 1919. Sadly, he continued attempting to define himself as the heir to the great Renaissance painting tradition, and his work soon dissipated in kitschy self-parody.

All artists speak a private language. When I first encountered de Chirico's paintings, I thought, "What is this?" I had to break the code of his hieroglyphics to begin to sense the beauty of his work. Now I speak de Chiricoian with a bad accent.

We always have to come to great poets and artists; it's not their responsibility to come to us. In the contemporary art world, with its cartoon aesthetic, there is no intrigue. And without the quality of strangeness or mystery the work is ordinary. Art should never be ordinary.

GIORGIO DE CHIRICO,
Study for *The Anxious Journey*, 1913

I don't know why I was surprised to learn in 1977 that de Chirico was still alive. One assumes that those mythical figures could not still exist in reality. Armed with a need to say thank you in my own way, I managed to arrange to go to Rome and found myself at an address near the Spanish Steps. The artist's apartment was grandiose in a way that one would have expected, given his heroic pretentions. He was not gracious, and he made me feel awkward and uncomfortable. My photography should have been better. Although it was not my best work, I was able to salvage the shoot with a few portraits that suggested his peculiarities. Afterwards de Chirico, his agent, and myself retreated to a nearby coffee shop. Outside of his home the maestro suddenly became affable, spoke English, and was all smiles. Later I asked his agent why there was such a difference in de Chirico once we left the confines of his apartment. His agent replied, "Did you meet Mrs. de Chirico?"

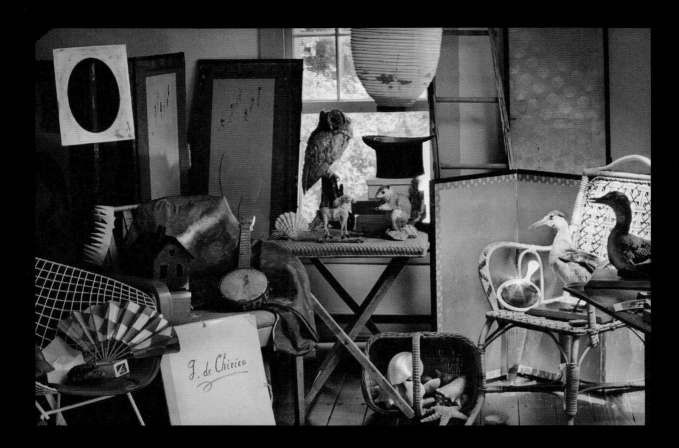

Deconstruction

Children often delight in taking something apart and putting it back together, not always in the proper order, inadvertently creating something new. The most popular word in a child's vocabulary is "why." Curiosity is the beginning of awareness as they enter their lives. Things have a certain fundamental order in their construction, art has a certain order in its construction. One of the great pleasures in art is in the glory of the arranged colors and planes that define it. Photographs are organized in such a way that they reveal an event, a place, an emotion, their own reality. I thought it might be interesting to take all of the elements of a picture and rearrange them in a new way, thus making out of them something that was not intended but might be marvelous and surprising.

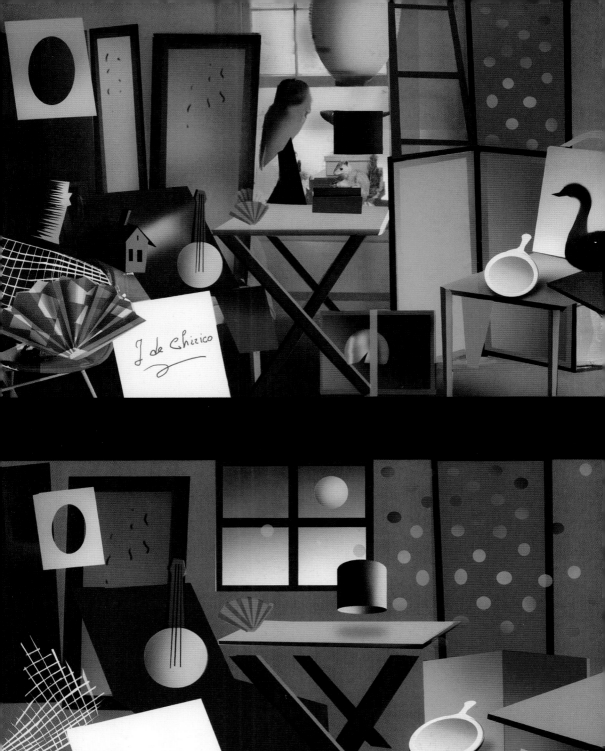

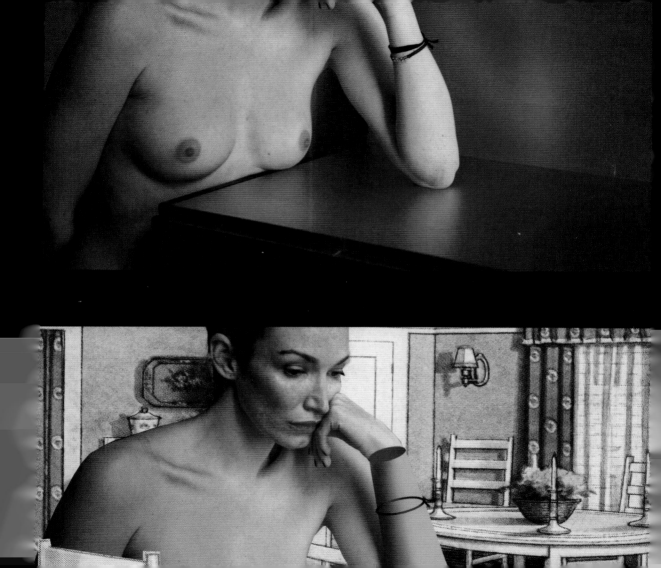

ABOVE & OPPOSITE:
Little Mary Mix-up (Deconstructed Woman),
2012

In the mid-1970s I had been working in London, photographing the Royal Ballet with Leo Lerman for *Mademoiselle*. After a week of photography, we finished on a Friday night and retreated to Leo's flat for a celebratory drink, congratulating ourselves on a job well done. Leo asked me what I'd like to do on my last night in London, and of course I hadn't a clue. He inquired, "Have you ever seen Marlene Dietrich perform? She's closing her act tonight, and I might be able to get tickets." As luck would have it, his phone was ringing as we entered his apartment. Marlene was calling, and she was wondering if he could suggest a recent Von Karajan recording she needed as a gift for a friend. Yes indeed, she could get us closing night tickets.

We had the best seats in the house, perfect for viewing La Dietrich's famous act. The story was that it took forty-five minutes to sew her into her dress, and I could see why. The form-fitting costume glittered as she came on the stage to thunderous applause. She sang in her smoky voice a series of hits including "Falling in Love Again." I assumed that she was in her sixties, but on stage she possessed an alluring androgynous glamour and seemed to be a different species of woman. Every gesture was as calculated as Kabuki. There was an aura of theatricality that placed her in the legendary company of performers who were beyond reality, like Mistinguett and Josephine Baker. When the curtain fell to a standing ovation and the house lights came up, Leo asked me if I would like to go backstage and meet her. Yes.

Backstage was not well lit. Props leaned against walls, casting strange shadows, ropes dangled from the ceiling, and the theatre's crew prepared to disassemble the sets. Marlene strode forward towards us and gave Leo a huge embrace, then turned her glance to me. Leo said, "I would like you to meet Duane, my photographer." She replied, "Leo, how long has he been in London, and why haven't you introduced me before now?" She glanced at me so intensely that I felt my eyebrows could have been singed by the heat. Slowly she slid her arm through mine and leaned her head on my shoulder. I was as stunned as if I had been shot by a Taser. After my fifteen seconds of blistering attention, she turned to Leo to discuss business, and my shoulder became her prop. "Cohen wants me to bring my act to Broadway next year, do you think it's a good idea? I'm also getting offers to do something special in San Francisco."

D*ietrich*

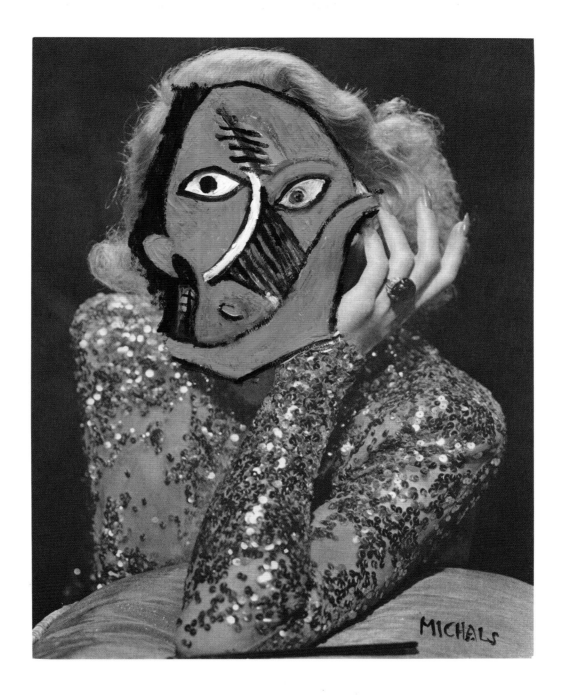

I didn't really hear the rest of the conversation, as I kept reminding myself that *the* Marlene Dietrich was leaning on my shoulder. Apparently, when she met men she would give them the full intensity of her attention, which flattered, disarmed, and intimidated simultaneously, and a second later, she would move on to her next prey. After our perfunctory goodbyes, as she walked away, I noticed she had a flat ass. Noel Coward was right: sex is a matter of lighting.

Marcel Duchamp is the Houdini of the art world. This merry prankster descended a staircase with a nude, rearranged all the rules of art by fiat, and declared a urinal to be Mr. R. Mutt. Miss Rrose Sélavy, his alter ego, was the first drag self-portrait, and she launched a thousand copycat queens. Although he had a short career in the art world, it still reverberates hugely in work like that of Robert Gober, who designated a sink on a wall as his art. What's the difference between a urinal and a sink? Andy Warhol was the perfect acolyte, with his Campbell Soup cans, as was Jasper Johns with his Ballantine Beer cans, maps, and coffee cans full of paintbrushes, and Bruce

Duchamp

Nauman spitting water in his famous *Self Portrait as a Fountain* (1966–67), which would have earned him detention in high school. Duchamp has legitimatized every talentless art school graduate with that dubious title of being cutting edge. Those who can't, Du champ.

I was commissioned by *Harper's Bazaar* to photograph Marcel Duchamp in 1964. The address given to me was 28 West 10th Street and I happened to live at 27 West 9th Street. For four years the voyeur in me had been watching from my back window an old couple who lived in the apartment directly behind. The wife sat in the warm winter sunshine knitting, cozy as a cat, the husband would occasionally give her a cup of tea, and they would share a moment of conversation. I was charmed by their intimacy. At the beginning of June, their shutters would close and it was for me officially summer. In October when they returned from their holiday, the shutters reopened, and that was my autumnal equinox. Upon entering the Duchamp flat, I realized they were the couple I had been watching for years, not knowing who they were. There was something tender and poetic about them together. They asked if I would take tea with them, and as we sat in the window chatting, I looked across to my apartment hoping to catch a glimpse of my great friend Fred.

OPPOSITE:
Marcel Duchamp,
1964

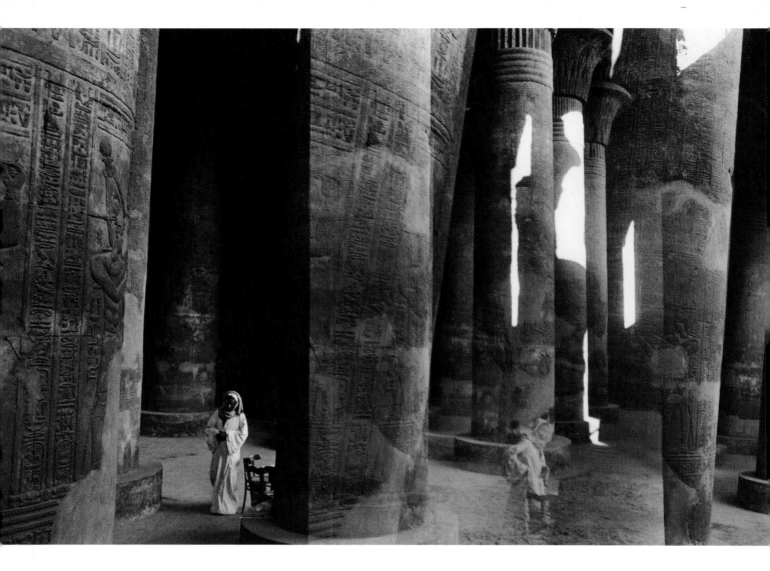

Egypt

My custom in Paris is to go to the Café de Flore for coffee and a croissant on Sunday mornings. What a surprise it was for me to meet there by chance the French photographer Jeanloup Sieff. He had been trying to contact me in New York to offer me the opportunity to work with him on a book he was editing for the publisher Éditions Denoël, and here I was. Shazam! The question he put to me was, "Is there any place in the world you've always wanted to go, but never had the time or money?" The publisher would provide enough money to fulfill that dream assignment, and in return it was the responsibility of the photographer to produce photographs and sixty manuscript pages of text for a book. I immediately replied, "Egypt!" And that is how I found myself on a plane to Cairo a few months later.

Two weeks before my trip I saw on television the movie *Caesar and Cleopatra*, starring Vivien Leigh and Claude Rains. I was enchanted by a scene on a moonlit night, with Cleopatra wandering among the ruins at Karnak and encountering Caesar as though in a dream. I thought, how romantic. I should photograph the pyramids by moonlight for my book. Upon arriving at midnight at my hotel, the Mina House, exhausted after an arduous flight from London, I opened the curtains of the windows in my room and was startled to see the pyramids practically across the street. There was a full moon!

Completely revived by the possibility that my vision might be realized, I rushed to the desk with my equipment and announced that I was going to photograph the pyramids . . . right . . . now. The desk clerk cautioned me that going out in the darkness could be dangerous. On a creative high, I laughed hysterically at his advice, and proceeded to hike into the sand dunes alone. I discovered, trudging through the sand, that the apparent proximity of the pyramids was an optical illusion; they were much farther away than they appeared at first glance. But I was thrilled just to be there and completely enchanted, under that magical moonlight.

As I set up my camera at an appropriate location and glanced through the lens, I noticed something moving a few dunes away. With a second glance, I realized that three men were heading toward me. Oh shit! My first night of my first day, with all of my equipment, alone in the middle of nowhere, with three ominous men approaching; the phrase "Stay out of Central Park in the dark" came to mind. As these scary shadows arrived at their destination—*me*—I said, "How would you like your picture taken?" Suddenly they looked like the Three Stooges, smiling as they waited for me to adjust my camera on its tripod to take their photograph. "I got it!" I announced with a terrified smile. And as quickly as they appeared, they moved on, silhouettes receding across the dunes into darkness. Still in my fight-or-flight mode, and on an adrenaline high, I finished my task and high-tailed it out of there.

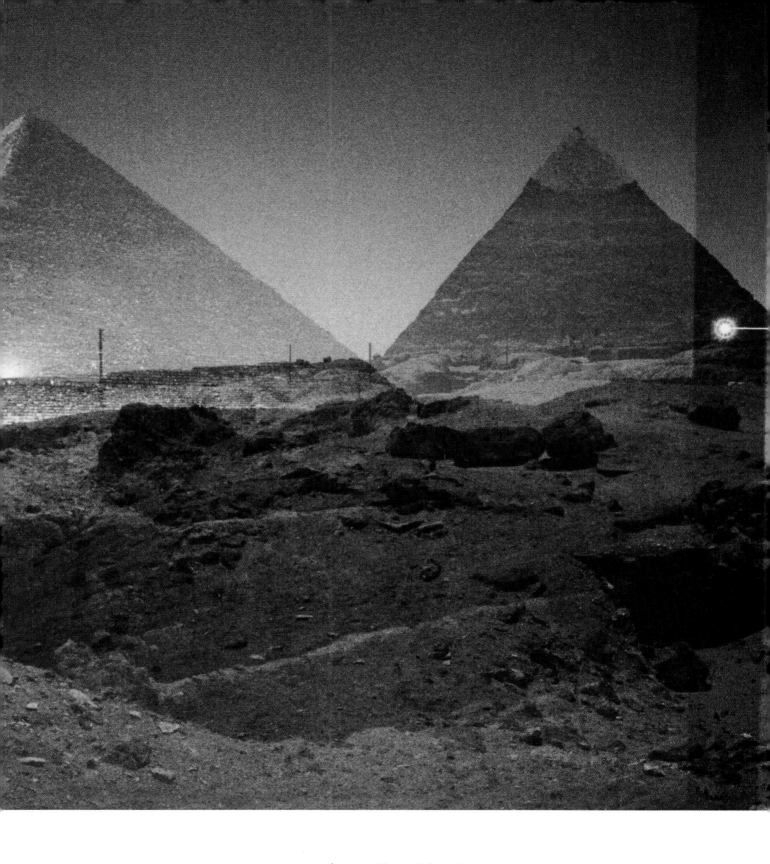

The Pyramids by Moonlight, 1978

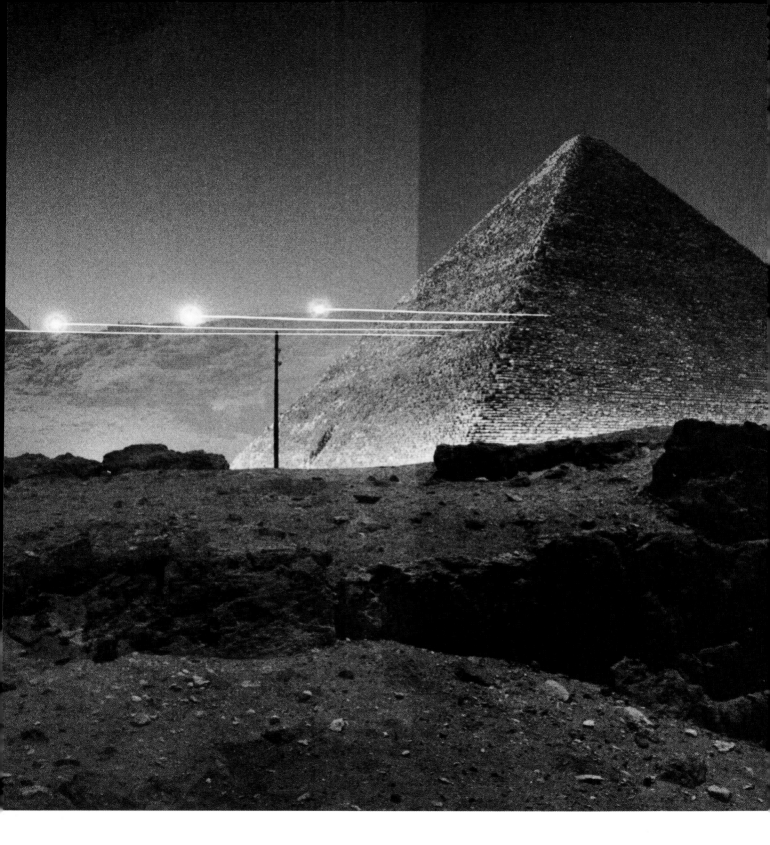

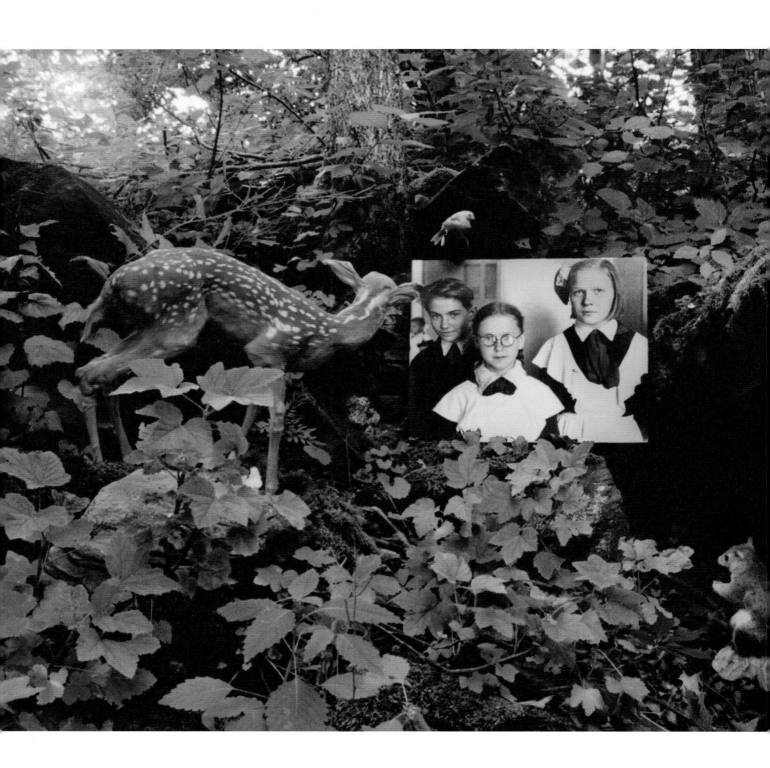

Exhibition

An Exhibition in the Forest
for Animals Only

Hush!
There it is again!
Hush!
A doe is tiptoeing through the brush.
Look, a feral canary flutters to a halt,
and over there a squirrel stares
at something beyond my sight.

Oh!
I shouldn't be here.
I retreat silently away
and leave the animals
to the pleasures of this display.

———

OPPOSITE: *Furry Friends and Things with Wings*
Visit Russian Children in Leningrad, 2012

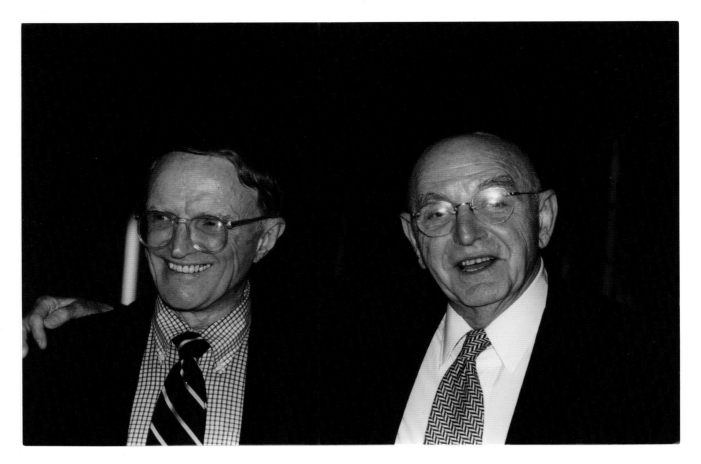

Fred Said

When I sat daydreaming, looking out the window in Mr. Gibson's class in my sophomore year at McKeesport High School, the notion occurred to me that I would one day go to New York and have a great friend and many adventures. At the time I had no idea what that implied. As it turned out, serendipity offered me a wonderful smorgasbord of opportunities, of which I took advantage. My adventures led me to my great friend Fred Gorrée.

For the last 55 years we have shared our lives as companions and have been rewarded with a wonderful history together. The satisfaction of growing old together has provided us with a happy ending. Unfortunately, we were not immune to the vulnerabilities of the body. My dear Fred has a combination of Parkinson's and Alzheimer's. The disaster of this dementia has not been without its surprises. A brand new, charming Fred has emerged. Now Fred has become Chauncey Gardner, the character who utters Zen-like non sequiturs in Hal Ashby's 1979 film *Being There*, based on the book by Jerzy Kosinski.

ABOVE:
Duane Michals and
Fred Gorrée, © 2003
Star Black

Below is a sampling of the wit and wisdom of Fred Gorrée.
I delight in watching his sly smile as he emphatically declares things that confound.

———

"I saw you eating a banana. What was the meaning of that?"

"From now on we will call you Sasha."

"I'm not sure where you are, but I'm sure it's someplace else."

"Because it's a holiday tonight everyone wants lemons."

"Hello, hello, I'm Fred Gorrée. . . . Who am I?"

When asked, "Why are you sad?" he replied,

"Because it's Sunday and every Sunday is somber."

"It's so grim outside. Just keep it moving along."

"You don't know what you're doing and I'm going to tell on you."

"Wowo wowo wowo wo wo"

"Everyone knows mystery when it blooms."

"Who exactly are you supposed to be?"

"You look like someone who has followed me all day."

"Why are we here? To help each other."

"Do you believe who you are?"

"Do you see Hong Kong, or am I hearing this?"

"He got lost in the back of the closet. I'm Mr. Privacy, you're just decorative."

"Your earrings look rather effeminate, don't they?"

"I have a fax machine of truth."

"What exactly is the purpose of you?"

"You are very hairy. That must be exhausting."

"You must say something amusing to get Robert's attention."

"Very funny, ha ha ha, are you going to be something? Zip Zap Zip."

"Did you say that or did I say that?"

"You would do well to do what I was going to say."

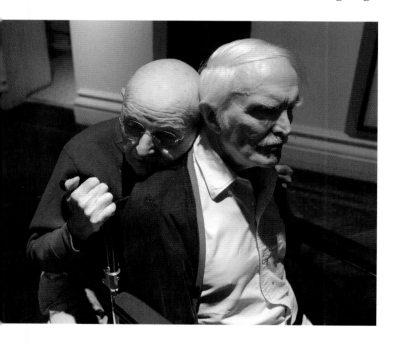

"I thought you were becoming
one of your own things."

"You are persnickety,
and also prissy."

"Take off your shoes
and make yourself useful."

"I wonder what Marco Polo's
doing now?"

"He's a clunk of a failure."

"I know this is a dream, but hello."

"Nobody knows anything about anything down here."

"I died recently."

"You've got funny written all over you."

"Oh how I could have had you."

Fred Steals

While doing the laundry recently, I began to notice a plethora of napkins. I could not understand why we had so many. It was then that Fred's caregiver, Robert, pointed out to me that Fred had been surreptitiously stealing napkins from restaurants we visited. This had gone on for weeks. One day at dinner in a restaurant, as the guest opposite Fred left for the men's room, I saw him furtively glance around the table. His fingers very slowly marched across the tablecloth to snag our friend's napkin and then back again, dragging the loot. The napkin vanished into his pocket as if he were a magician. On another occasion, walking behind his wheelchair, I saw him drag a napkin in his left hand down the sidewalk as we headed home. His personal best was his attempt to purloin three napkins, but he failed, having been intercepted after two. Upon arriving at our favorite eatery another day, Robert sternly admonished him not to take any napkins, and Fred replied, sotto voce, "Do you think they know?" I am now beginning to feel like an accessory to Fred's napkin heists. I'm not going into the slammer because of his sticky fingers. This Christmas, all of our friends will be receiving stolen property.

OPPOSITE:
*Duane and Fred
at home,*
August 2013

Freud

Lucian Freud was a serial seducer, whose sexual appetites were worthy of a Mormon patriarch. He sired fourteen children, perhaps more, with a variety of women. He was attracted to teenage girls, and he was known to have sex with men occasionally. Sometimes Freud juggled two lovers simultaneously; as one arrived, another would retreat down the back steps as in a Feydeau farce. His bedroom should have had a revolving door. He was the most reckless of drivers, speeding his Bentley through stop signs and red lights like a desperado on the lam. A reckless gambler who didn't mind losing a fortune, Freud borrowed from friends with deep pockets. At one point he owed gamblers four million pounds, and sometimes he paid them off in paintings. He was secretive to the point of not giving his phone number to his children. He would make extravagant demands of art dealers, who were manipulated into buying his paintings up front.

I don't know how he managed to find time to paint, but paint he did. His singular obsession in life was painting. Sitting for him was an exercise in masochism. Hours were spent in awkward positions on cold floors in cold rooms. Lucian would stand very close to the model's face, examining each crevice, wrinkle, and eyelash. Everything about his work referenced the history of painting, from the way he applied his brushstrokes, the traditional subject matter of nudes, and even the title of a major work, *Large Interior, W11 (after Watteau)* (1981–83). He belonged to the tradition of the grand eccentric master, whose focus in life is an overwhelming passion to express all that he feels on the canvas. Balthus and his peers Francis Bacon and David Hockney also fit the mold. Freud transcended art stylists such as Cy Twombly, Jeff Koons, and Ellsworth Kelly. Whatever eccentricities he needed to survive were forgiven in light of the rewards of his heroic legacy.

OPPOSITE:
LUCIAN FREUD,
Large Head,
1993

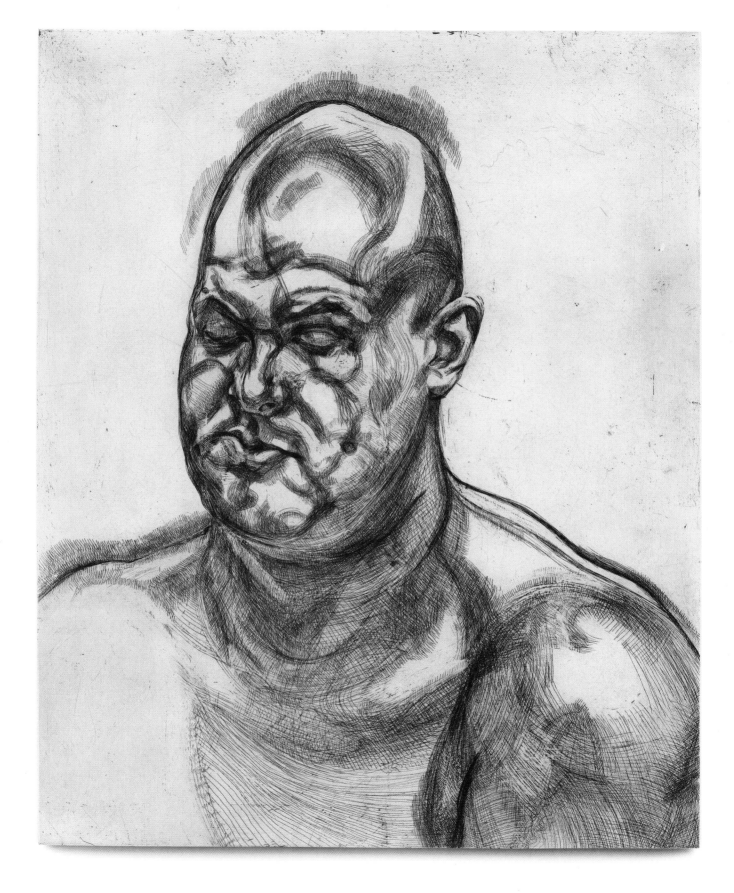

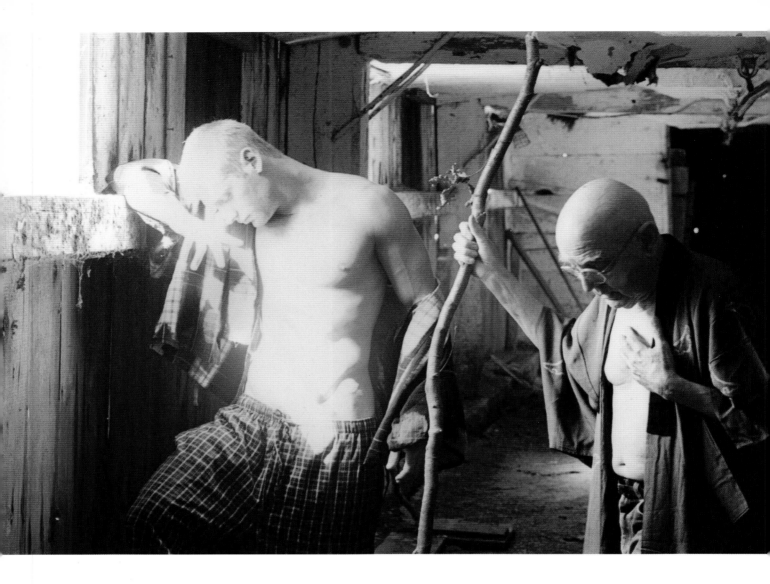

Ghost

Death is always a surprise, even when expected, and when it finally does arrive, it shocks. My mother had been in Chestnut Hill Hospital in Philadelphia for a number of months, and with each successive visit I found her failing more and more. Conversations became very difficult, and no amount of pretending could bring comfort with its transparent denial. Below the surface, tears lurked in a shadow cast by melancholy.

Early in January 2000 I took my usual train to Thirtieth Street Station to confer with my sister-in-law Ann, my aunt Eleanor, and a hospice worker. Mother's tether to life had become seriously frayed, and we needed to make some difficult decisions. All agreed that it was time for her to move to a hospice. After saying goodbyes to

my family, I told them I would take a minute to visit mother before I left. I found a doctor by her bed. He informed that she had just experienced another heart attack and that things would be over soon. I waited by her bedside. Dear Margaret, mother, wife, woman, thank you for more than everything. I began my vigil listening to her breathe, as if it was a language that she was using to say goodbye, until her sighs stopped. An hour later it occurred to me that this was the moment, according to the Tibetan Book of the Dead, that one performed a ceremony of passage. To her Catholic ears my Buddhist gibberish must have sounded as alien as Sanskrit. I could imagine her thinking, where's the priest, where's the incense, where's the extreme unction, where's the wine? That kid never did make sense.

I called Fred to say that mother had passed and that I was staying overnight in her apartment. Her condo seemed eerily quiet and empty as I opened the door. I decided to sleep on her daybed in the living room, instead of in her bed. After locating the sheets, I made myself as comfortable as I could, lying there, remembering the events of the day and thinking about her life. A street light outside the window saved the room from darkness, and I must have been a half an hour or so in that state of reverie when I saw her standing at the foot of the bed. She smiled and went from the right to the left side of the bed, and then vanished. Did I just see that? Was it a hallucination? I began to pinch my face, my nose, my hands, my arms. It wasn't a dream. Had she come to say goodbye? I cannot say whether this phantom did or did not appear. What did happen was a feeling that death contains more secrets than we can imagine.

I call my body my Duane suit. It is a 1932 model, some of which are being recalled. One can get spare parts; knees, hips, heart transplants. This energy that I am is essentially a consciousness inhabiting a costume called Duane, a fiction of my imagination. I am the ghost in the machine of my own story, whose plot I cannot explain.

G*od*

At last count I found eighty-three billion, seventy-three million, two hundred and twelve thousand, and five stars in our galaxy, the Milky Way. There are seven hundred and nine trillion, two billion, ten million, nine hundred and seventy thousand, two hundred and twelve galaxies in the universe, give or take two hundred million. I did not include the speck of cosmic dust we call the sun, which we circle around ad infinitum. It's too small to matter. Our clever species is an evolutionary by-product of consciousness. Our inflated egos have flattered us into succumbing to the delusion that we are cosmic Mighty Mice when actually we are mini mites.

People who are marinated in religion create the God they worship. An amusing concept of a God who in seven days invented the above-mentioned midnight sky extravaganza, just like that! We are all whistling in the dark on this planet.

Every May 15, Sister Mary Mary Mary, who taught seventh grade at Holy Trinity School, would have the students begin to pray to Jesus that we might have a nice day on June 15 for our annual picnic at Kennywood Park. Mr. Almighty sitting on his throne would amuse himself by randomly peering through clouds of galaxies to see what he could see. Suddenly through a swirl of stars, he zeroes in on a dot called the Milky Way, and further still, until he finds a green speck called Earth. He delves even deeper to McKeesport, where he hears a boring cacophony of cheap flattery. "Well, I'll be! Look at those cute little tykes, all blathering, trying to get my attention. I'm just going to give them what they want. Of course, it means I will have to redirect the jet stream north through Canada, where extensive rains will ruin the wheat and thousands will be flooded out. Down south, the boll weevils will run amok for lack of rain and ruin the cotton. But it's worth redirecting the entire weather pattern of North America to ensure that these tiny saints get their nice day." AMEN.

OPPOSITE: *I am much nicer than God*, 1980

I AM MUCH ~~MUCH~~ NICER THAN GOD

IT WAS LAST THURSDAY WHEN GERRIT FINALLY DIED,
THAT I REALIZED I WAS MUCH NICER THAN GOD.
I NEVER WOULD HAVE LET HIM SUFFER ALL THOSE YEARS,
I NEVER WOULD HAVE INVENTED CANCER
 IN THE FIRST PLACE.
I WOULD NOT PERMIT CHILDREN TO GO TO SLEEP HUNGRY,
 OR LET OLD PEOPLE CRY ALONE.

BUT IF IT IS TRUE THAT WITH MY PETTY VANITY AND GREED
I AM MUCH NICER THAN GOD, THEN I AM IN DESPAIR.
I DO NOT HAVE ENOUGH KINDNESS AND LOVE TO SUSTAIN
 SOMEWHERE THEIR MUST BE MORE ~~FOR~~ LOVE.

 D.M.

Grief

He died. The Universe stopped. No matter how desperately she held his hand, his life slid through her fingers into oblivion. Years of suffering had collapsed with a whimper. Death had eclipsed life. All those years of seconds and minutes and hours had come down to this. She imploded into that emptiness, which his loss created again and again. There was no consolation to be found; nothing could be said that would heal the loneliness of tragedy. Tragedy cannot be shared. It must be endured in its cocoon of memories. What once sustained now seems a mockery, taunting her to tears.

My dear friend told me this story in confidence, and she has given me permission to share it with you. Since her husband died, she has had a recurring dream. Somewhere in a place she can't identify, she finds a box and inside the box is a key. She roams down hallways and arrives at a door, which the key opens. Inside the room her smiling husband is sitting, waiting for her. They are together again.

OPPOSITE:
The Moan, 1994

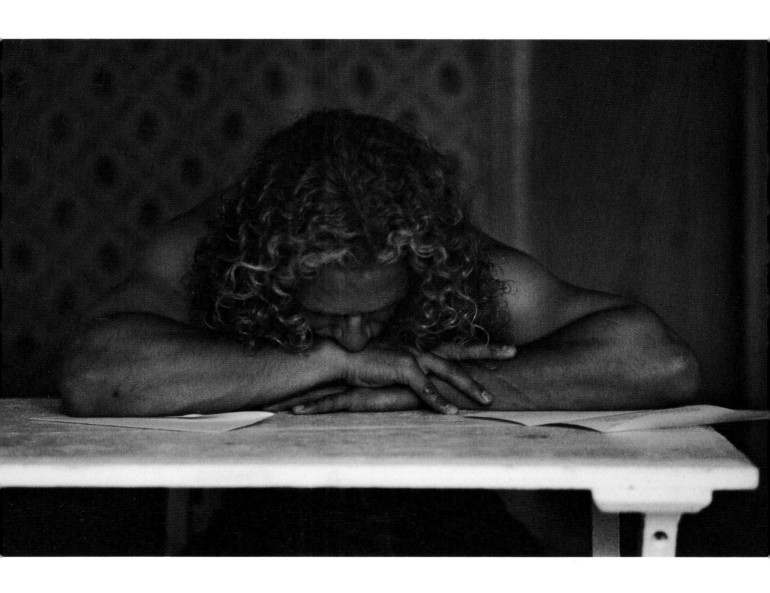

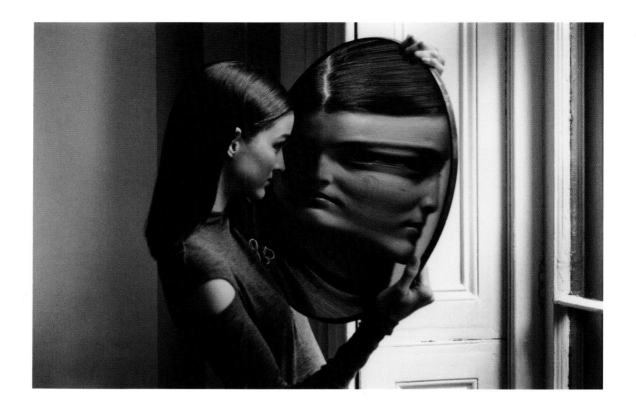

Heisenberg

French *Vogue*'s December issue has always been dedicated to a single subject, for example, Hockney on painting, Scorsese on film. In 1999 the editor Joan Juliette Buck called me because that year's December issue was to be about physics. She wanted to know if I was interested in illustrating quantum mechanics. Since I've always been fascinated by the subject, I could not resist saying yes, although I have no credentials even as an amateur physicist. But how do you photograph ideas that are essentially invisible? Any solution I could imagine would only be an approximation, doomed to failure—but what a grand failure.

In 1947 our high school chemistry teacher Mr. Dunlap taught that the atom was made up of a proton, neutron, and electron all spinning in orbit. And that was that. However, after the Second World War, larger accelerators were built, which would hurl particles at enormous speeds, colliding with one another and breaking up into even smaller units. Suddenly there was a whole new family of particles: quarks, leptons, antiquarks, antileptons, and others. Then, with the advent of even larger accelerators, whole families of smaller and smaller particles were discovered: muons and six different flavors of quarks (up, down, charm, bottom, top, and strange). Werner

PAGES 74–77:
Dr. Heisenberg's Magic Mirror of Uncertainty, 1998

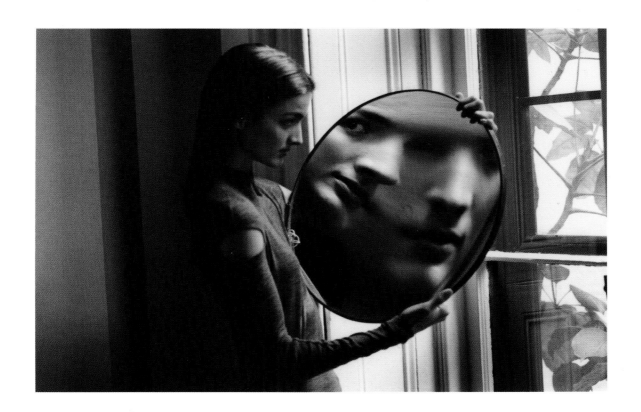

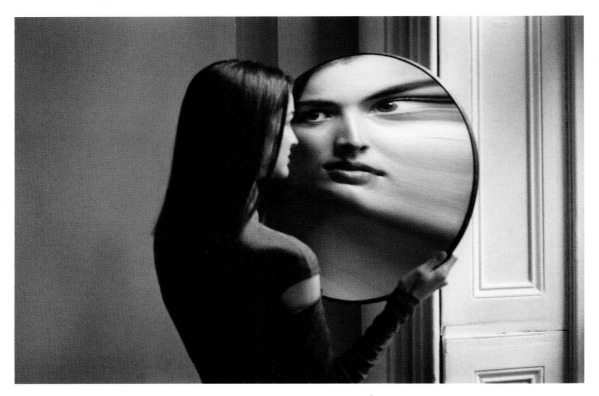

Odette can never be sure with any certainty which reflection of herself she will see in the mirror.

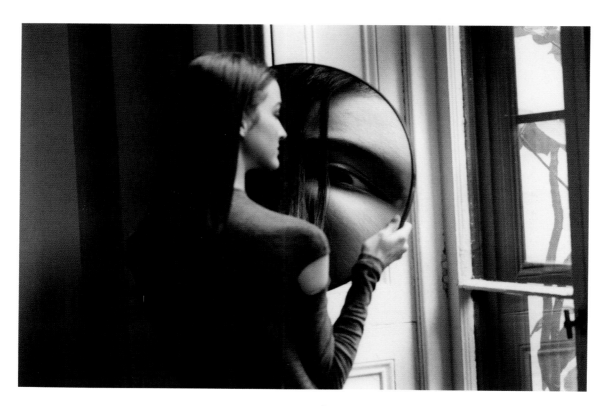

The act of looking into the mirror affects what the image will be.

Heisenberg suggested that the search for the ultimate basis of the atom would lead to random colliding and chance encounters of unpredictability. One could never be sure of the velocity or position of any particle, which prompted Albert Einstein to declare that he could not believe that God would play dice with the Universe.

I was visiting Bath, England, and saw in an antique store window a wonderful convex mirror, which I carried home on the plane. For *Vogue* I wanted to illustrate Werner Heisenberg's uncertainty principle using my bizarre mirror, which contorted reality in unpredictable ways. I did a sequence called *Dr. Heisenberg's Magic Mirror of Uncertainty*, a simplistic solution to a complicated problem. As my model would look into the mirror, her image would distort with every movement, producing an unpredictable series. The act of her looking into the mirror made her a participant in what the distortion would be—pure quantum mechanics. In the last photograph, she turned her face away from the mirror, producing an image with no face. Quantum permits the impossible. Chaos has its own logic.

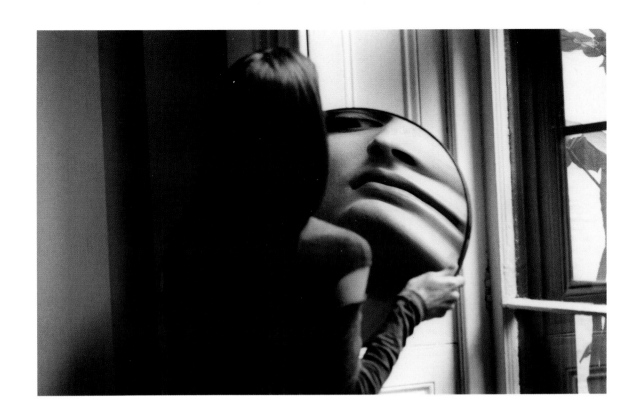

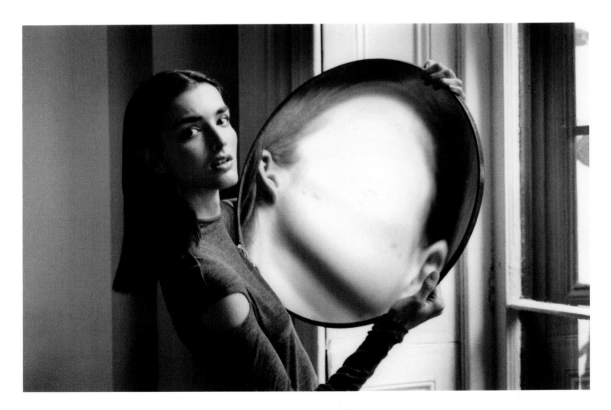

Uncertainty permits anything and everything.

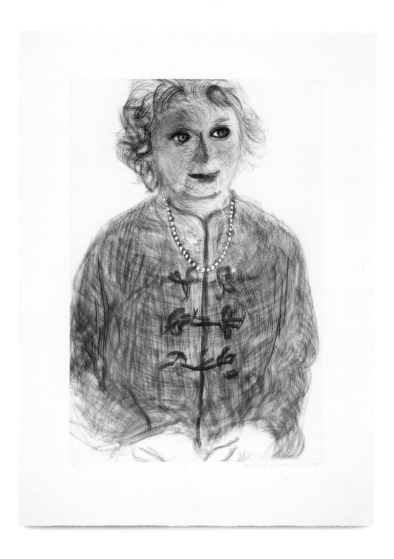

Hockney

I found my David Hockney lithograph of Henry Geldzahler at the André Emmerich Gallery in New York. What drew me to this work was the eloquence of the line and how deftly Hockney portrayed Henry. The portrait was originally a Christmas gift. David's grand talent as a portrait artist makes him the twenty-first century heir to Jean-Auguste-Dominique Ingres. There's nobody else today who can claim that title.

I once photographed David kissing a young fellow as a prose portrait. The relaxed rapport with his friend, and the obvious pleasure they took in each other's company, revealed his affection for the young man with touching honesty. To this day David still continues to produce an amazingly original body of work, and his inquisitive mind still demands our attention.

In a bouquet of flowers Hockney would be a hollyhockney.

ABOVE:
DAVID HOCKNEY,
Soft Celia, 1998

OPPOSITE:
DAVID HOCKNEY,
*Henry Seated with
Tulips*, 1976

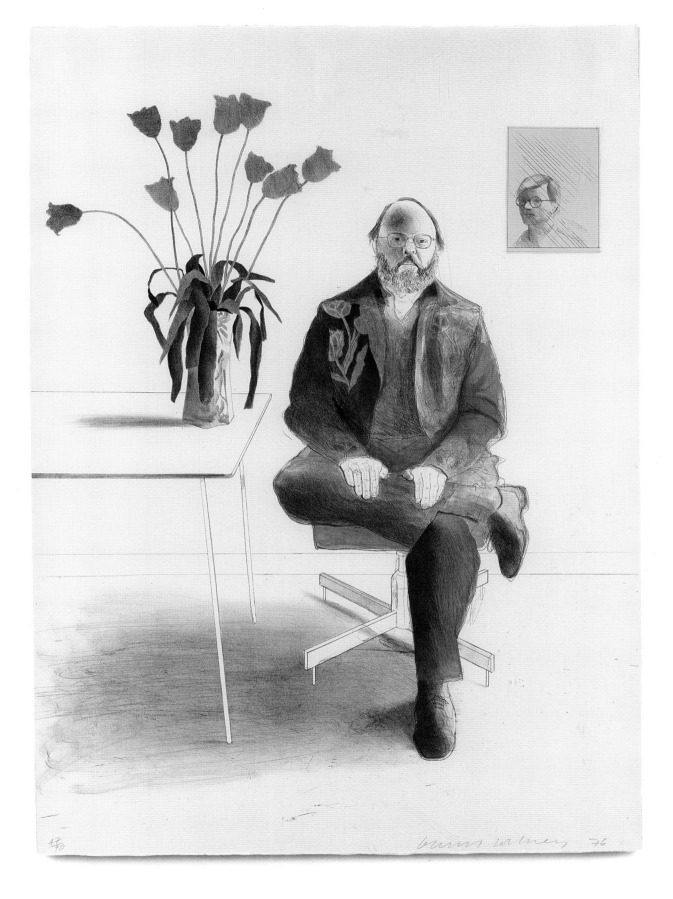

David Hockney 76

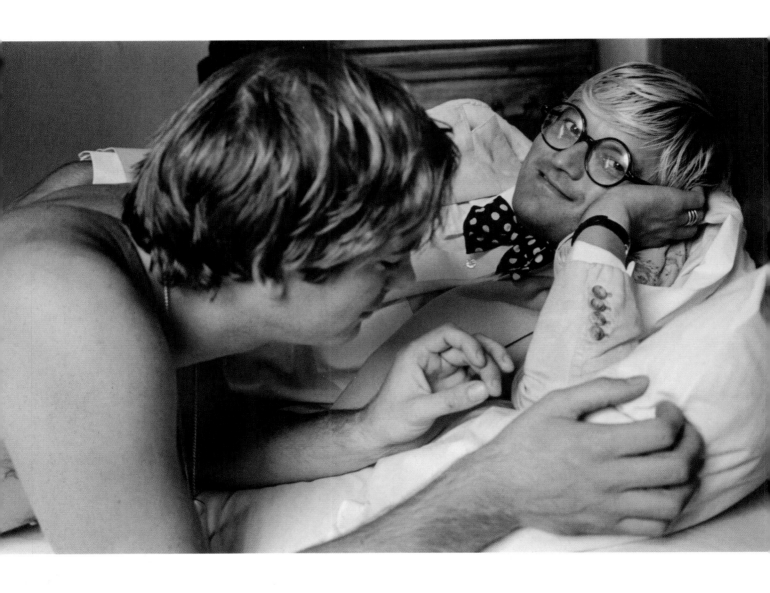

ABOVE & OPPOSITE:
David Hockney with friend, 1975

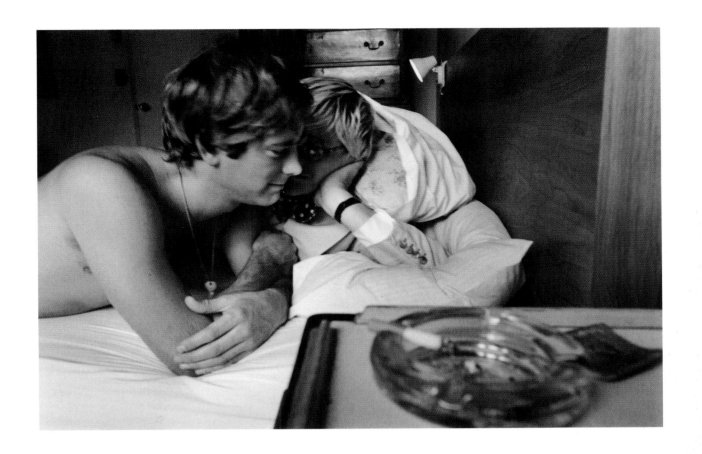

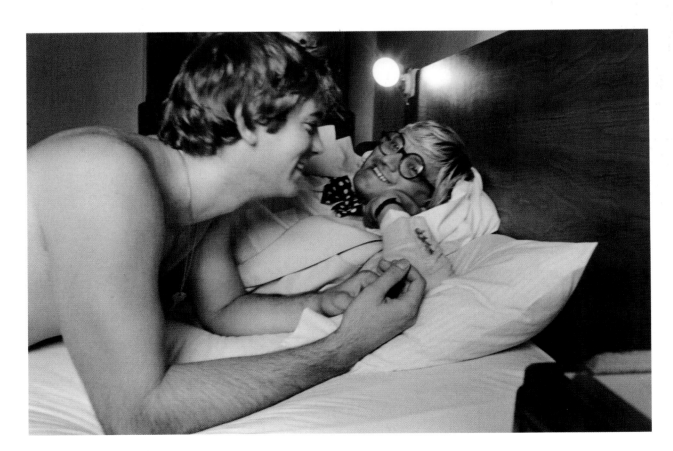

Homosexuality

Homosexuality is just like heterosexuality except that it's different. Some people are born straight, other people are born gay. Some people have red hair, some people have brown hair. Some people are born hairdressers and others are born to play the position of tight end. Nature provides our species with many ways of being in the world. The advantage heterosexuals have is the possibility to produce a child—real evidence of their love. The disadvantage of heterosexuality is that many children are accidentally born into loveless unions with battered mothers and deadbeat fathers. Homosexuals do not reproduce, but they have great wardrobes and get laid a lot, altogether not a bad quid pro quo.

Even the most brutish heterosexuals are not punished for being heterosexual by society. When men rape and abuse women, it's winked at by society: "boys will be boys." Sensitive boys who wouldn't hurt a fly are labeled sissies, and they are vulnerable to ridicule and worse. The hypocritical Catholic Church, with its closeted clergy, has shamelessly protected pedophiles, who for decades have raped children while portraying themselves as being holier than thou. Ancient shriveled monks and bishops in their gold lamé and red shoes strut in front of altars pretending to have a tête-à-tête with God.

OPPOSITE:
The unfortunate man could not touch the one he loved, 1976

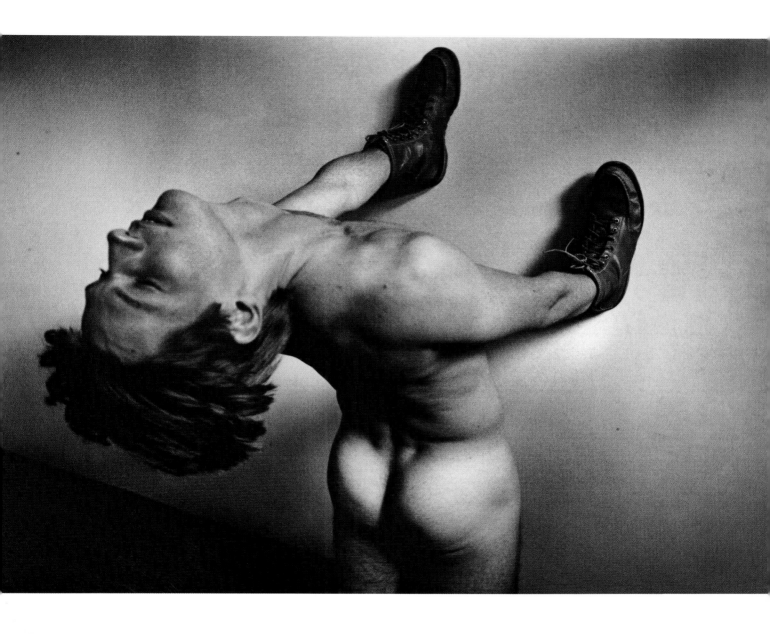

The unfortunate man could not touch the one he loved. It had been declared illegal by the law. Slowly his fingers became toes and his hands gradually became feet. He began to wear shoes on his hands to disguise his pain. It never occurred to him to break the law.

Innocence

Somewhere in Warsaw in 1939, a Polish doctor named Kaminski and his family share a middle-class flat filled with books, a piano, and a portrait of Chopin. On the afternoon of October 31, with tanks on the street below, sirens, and the sporadic firing of guns, the family cowers in a corner, away from the windows. Thunder is heard in the hall as Nazi soldiers go from apartment to apartment kicking down doors looking for Jews. *Crash. Crash. Bang.* Their door collapses as the cowards in black enter. As the mother and father are knocked to the ground, their ten-year-old Stanislaw is left shouting, through his tears, "Mama, mama." The killers hardly give him a glance as they drag his parents out the door. The little boy stands straight up and shouts, "I'm going to call the police on you." Again he says, "I'm going to call the police on you." But nobody heard him.

With the advent of Fred's fragility, I find myself being very protective of him. I seem now to have become his guardian angel, and my purpose is to guard him against the world. But it brings to mind in a larger sense the terrible plight of the disenfranchised innocents brutalized by barbarians at the door.

I heard those words of the Polish boy echoed one night by Fred. On the days when I took care of him by myself, the evenings were always particularly difficult. About 4 AM I awakened to help him pee. No amount of negotiations could lure him back to bed. As I implored him to return, he became more and more agitated and paid me no mind. Finally his distress reached critical mass. He turned to me and said, "I want you to leave. I'm going to call the cops on you." And there I was, the author of his torment. His Duane could not protect his Fred.

OPPOSITE: *Help!,* 2014

84

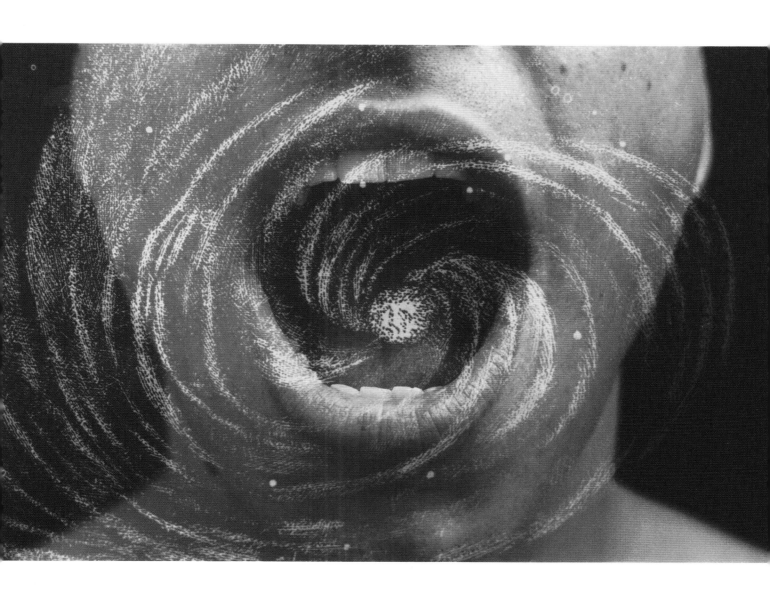

Intimacy

We seemed to be standing in the wings, waiting for our chance at last to go on. Our conversation had become a rehearsal of familiarity. I don't remember which particular word in our script opened the door that had been closed. Now silence betrayed an unspoken touch. The vacuum that created a distance between us began to fill with palpable intensity. We stopped acting.

Your closed eyes granted me permission to do what I wanted; we had crossed into a shared need. Awkward fingers pretended to be learning how to unbutton. Through the fabric my hand brushed your torso without apology. Your shirt opened like a stage curtain, revealing a theatre of delight. The overture began as I unfastened your belt on cue. Trousers descended slowly, revealing your hidden strength. The lights faded to darkness. Oh, you were more beautiful than I deserved.

OPPOSITE:
Male and Female,
1963

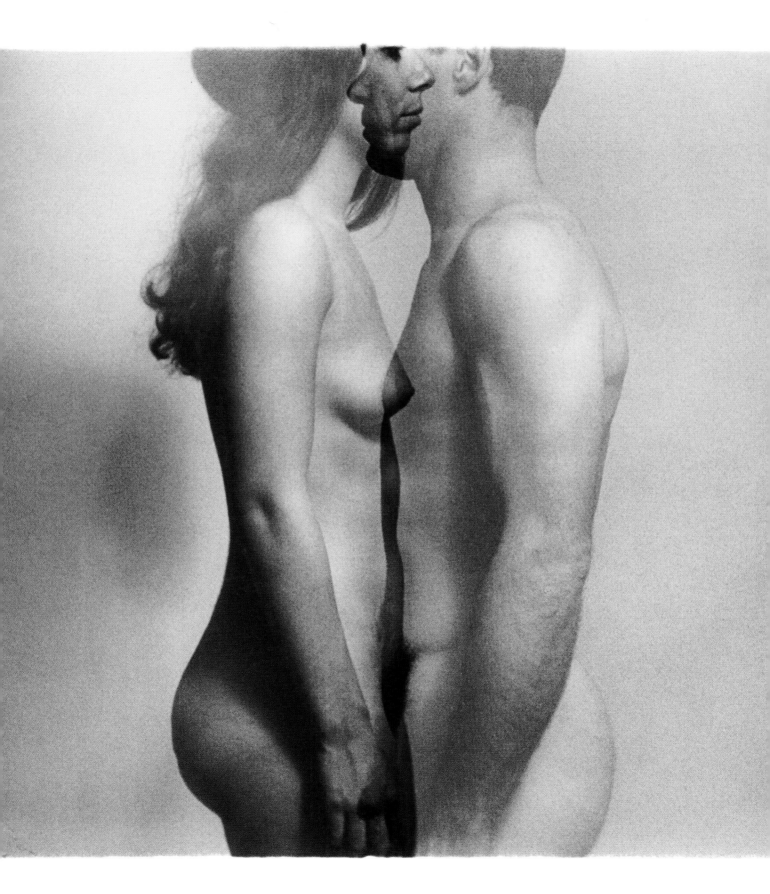

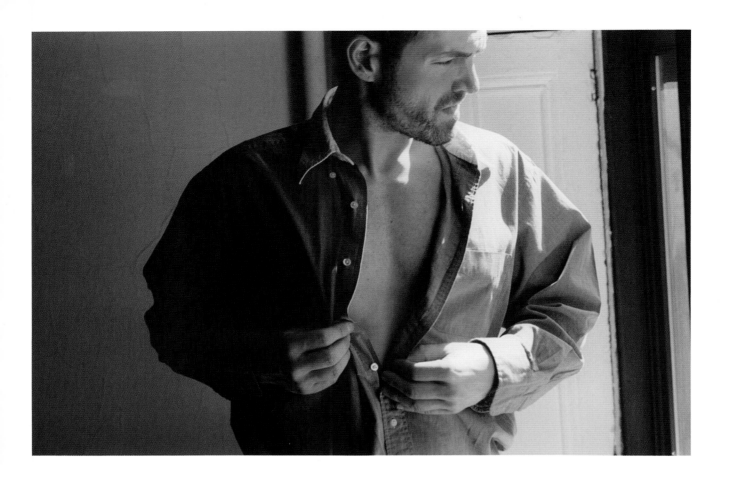

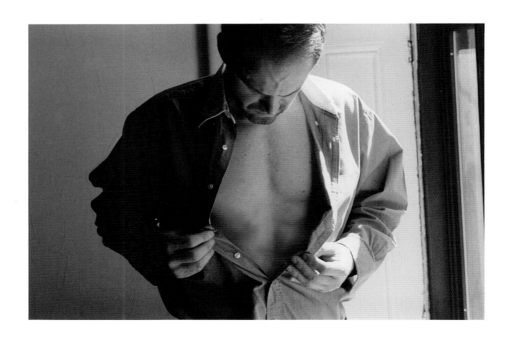

THIS PAGE & OPPOSITE:
The Pleasures of Disrobing,
2014

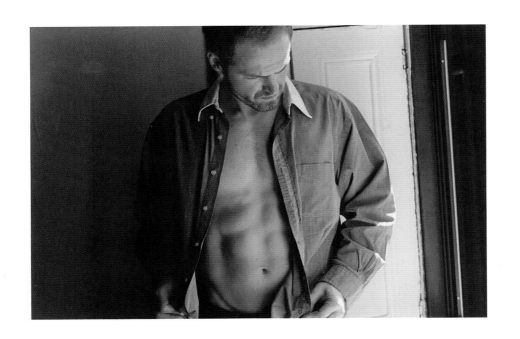

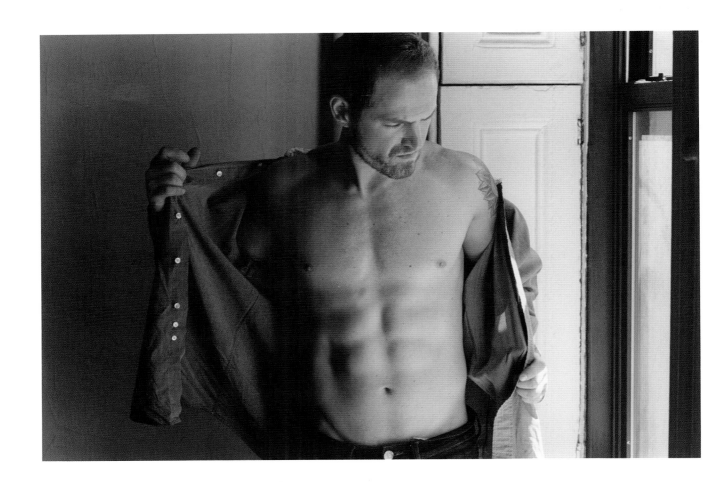

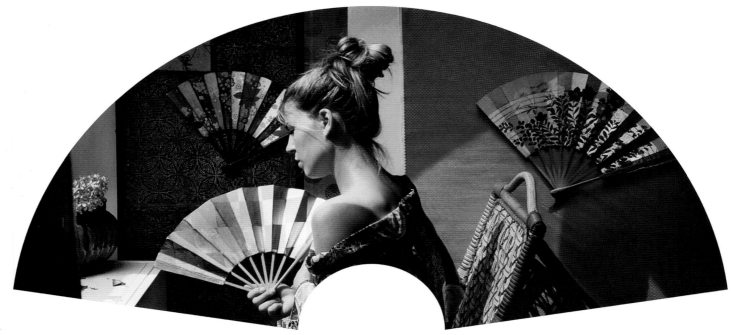

A portrait of Miss Moon with her collection of fans in the manner of Hokusai
7/08/07

Japonisme

When Baudelaire declared that artists should paint modern life, I'm confident that he was thinking of ukiyo-e, the school of Japanese art that found subject matter in the everyday life of the people. In Baudelaire's time in France, an artist could not become recognized unless he painted the official subjects of the Salon, with references to heroic history and mythology. Édouard Manet, with his outrageous *Olympia*, *Le Déjeuner sur l'herbe*, and *The Execution of Maximilian*, introduced modernity as a legitimate subject of art. He was rewarded for being ahead of his time with the ridicule of the establishment. Contemporaries like Degas, Toulouse-Lautrec, Vuillard, and Bonnard were simultaneously taking a great leap forward into the present. All of these artists shared a passion for Japanese prints.

When Japan was opened by Admiral Perry in 1853, and Bakumatsu, the "end of the curtain," ensued as the Tokugawa shogunate collapsed, the West embraced exotic Japanese goods, which quickly became the fashion of the late nineteenth century. Merchants found Japanese products wrapped in various kinds of paper packaging for protection, and upon examining this debris, they began to notice the beauty of

PAGES 90–97:
Each work for
this entry is titled
and dated on the
piece itself.

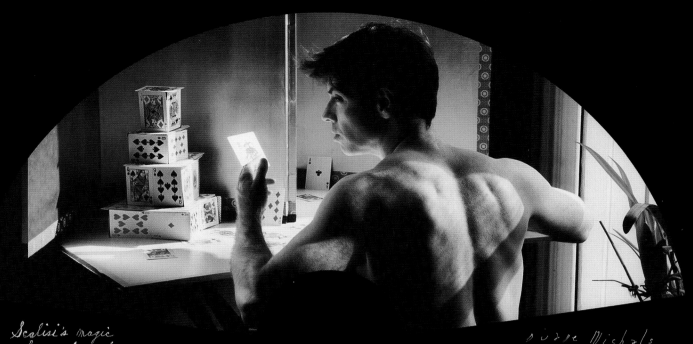

Scalisi's magic
house of cards,
a palace of kings, queens and jokers

2 18 08

Duane Michals

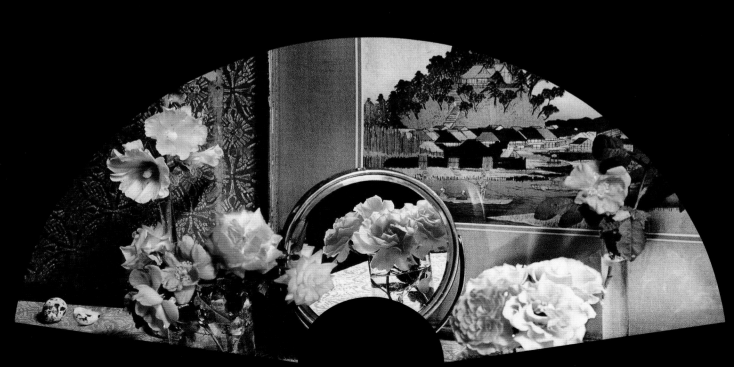

The spirit of my mother was happy, when she saw me photograph her roses.

6/30 07

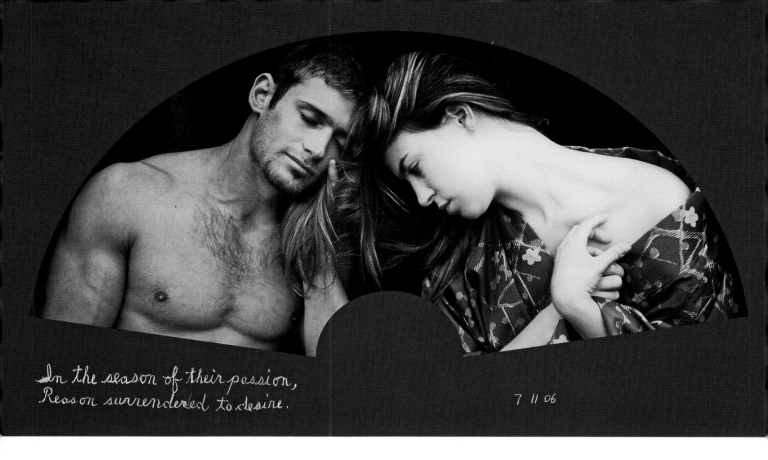

In the season of their passion,
Reason surrendered to desire.

7 11 06

these expendables. Everyday prints were very popular and inexpensive in Japan. They included portraits of famous actors and actresses, geishas in the pleasure district, many views of Mount Fuji, stations on the Tōkaidō road, ordinary views of cities, and the ever-popular cherry blossoms. The style of this work was totally contrary to the Western art canon. What made these prints unique and different from Western art was their use of flat color, lack of chiaroscuro effects, awkward compositions, and erotic subject matter.

These prints quickly attracted Parisian artists, with their appetite for novelty. Toulouse-Lautrec's posters, with their broad splashes of flat red and black, became a hallmark of the new style. He even had his portrait taken dressed in a Japanese costume. Degas's washerwomen and dissolute café patrons, van Gogh's rainy fields in Provence and black and white line drawings, Vuillard's patterned wallpapers, Whistler's bridges, Cézanne's obsessive painting of Mont Saint-Victoire, and Monet's haystacks series trace their lineage to Japanese prints.

What I found particularly interesting were Gauguin's fan paintings. He painted twenty-three of them, composing within the fan shape, which presented him with a composition problem. Fans were a popular fashion accessory for smart Parisians. They were commonly seen in portraits of society ladies lounging on their divans. It occurred to me that photographs, which are usually seen in a square or rectangular format, could also be adapted to the fan shape, even with the challenges that presented.

Excited by the possibility of investigating the Japanese "floating world" as subject matter for photography, I began to see my environment in the manner of the grand master Hokusai. Although we have lived in New York since 1955, Fred and I shared 43 of those years gardening, surrounded by woods worthy of Hansel and Gretel, complete with bears and owls as neighbors, at our country house outside of Cambridge, New York. I am an Arcadian. I have always lived in a garden. I count the leaves on our cherry trees and watch them grow. The cherry grove is a blizzard of white blossoms in April.

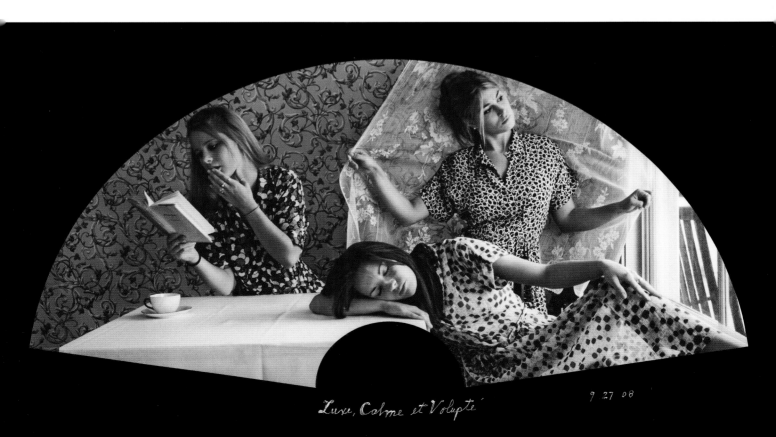

Luxe, Calme et Volupté 9 27 08

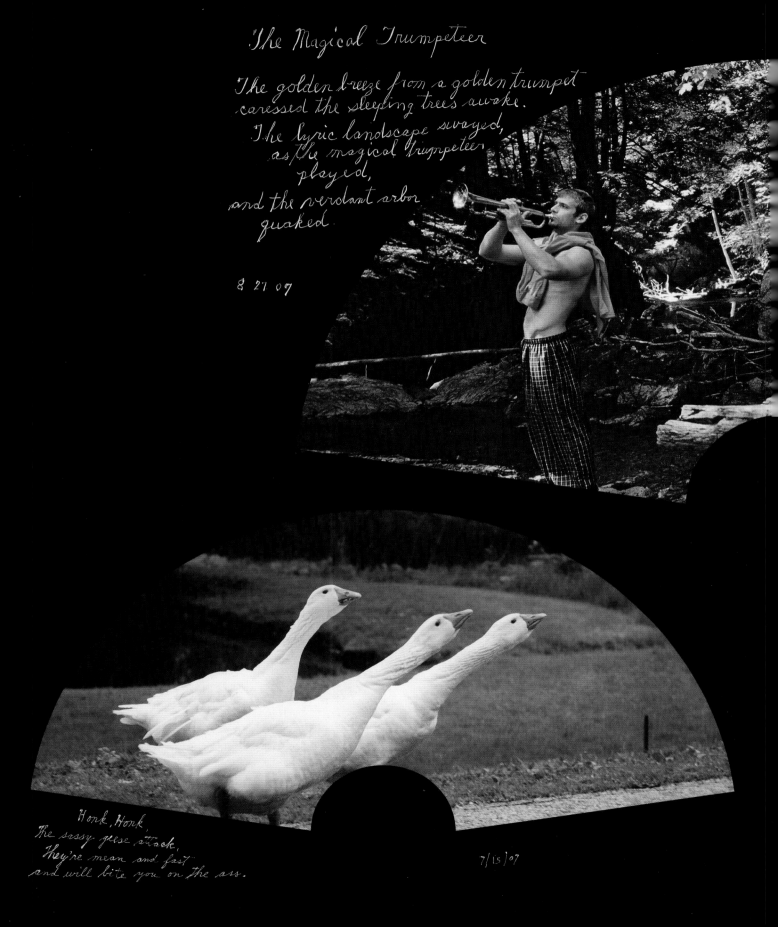

The Magical Trumpeteer

The golden breeze from a golden trumpet
caressed the sleeping trees awake.
 The lyric landscape swayed,
 as the magical trumpeteer
 played,
and the verdant arbor
 quaked.

8 27 07

Honk, Honk,
The sissy geese attack,
 They're mean and fast
and will bite you on the ass.

7/15/07

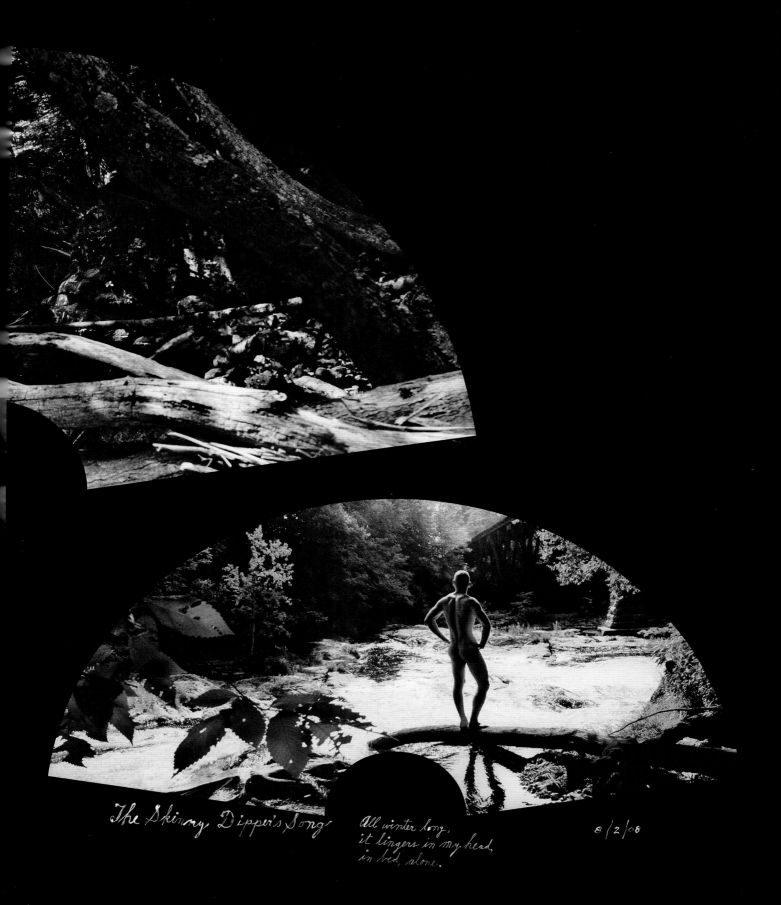

The Skinny Dipper's Song *All winter long,*
it lingers in my head,
in bed, alone. 8/2/08

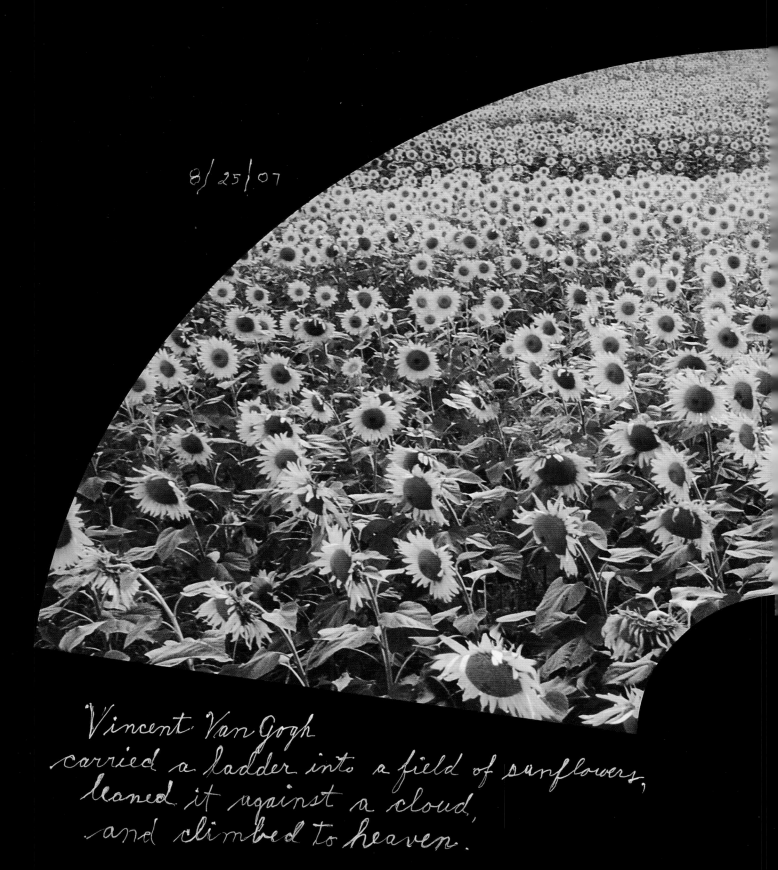

8/25/07

Vincent Van Gogh
carried a ladder into a field of sunflowers,
leaned it against a cloud,
and climbed to heaven.

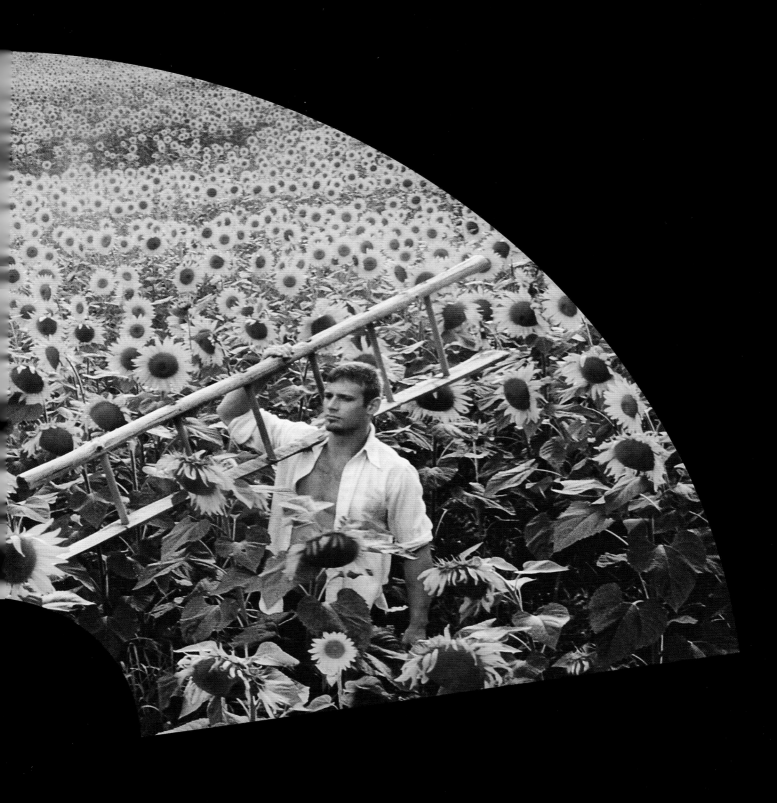

James Joyce was Nora's mick big charmer, the Till Eulenspiegel of twentieth century literature. A teller of the tallest tales, singer of salty songs and bogus raconteur who serenaded and seduced with language. He could write a wrong. When Nora said "yes, yes, yes," it was the loveliest swoon of sex. Miss Barnacle's BJ was the shot heard around his world. Everyday was ladies day, especially June 16th. When he taught English at Berlitz in Trieste, he became enamored with a teenage student of his. He kept a notebook titled Giacomo Joyce that contained his romantic impulses. Below are some excerpts from that notebook.

"This heart is sore and sad. Crossed in Love?"

"Long lewdly leering lips: dark-blooded molluscs"

"Her body has no smell: an odourless flower."

"Why?"

"Because otherwise I could not see you."

"Sliding—space-ages-foliage of stars—and waning heaven-stillness—
and stillness deeper—stillness of annihilation—and her voice."

"She listens: virgin most prudent"

Dublin was his Jerusalem. He would never return for fear of being sued, and because of the perpetual exile, Dublin remained the constant home of his heart. He tapdanced his way from Zurich to Trieste to Paris. Always broke, he always landed on his feet with sweet sugar mamas paying his bills. Gertrude Stein hated him. Joyce was the real thing, the Cubist poet she wanted to be. Miss "A Rose is a Rose is a Rose" broke with Sylvia Beach when Shakespeare and Company published *Ulysses*. The weight of THAT BOOK crushed Gertie's literary posturing. Thank God for "Four Saints in Three Acts," and the rest is mystery.

Finnegans Wake made me quake.

OPPOSITE:
James Joyce,
2012

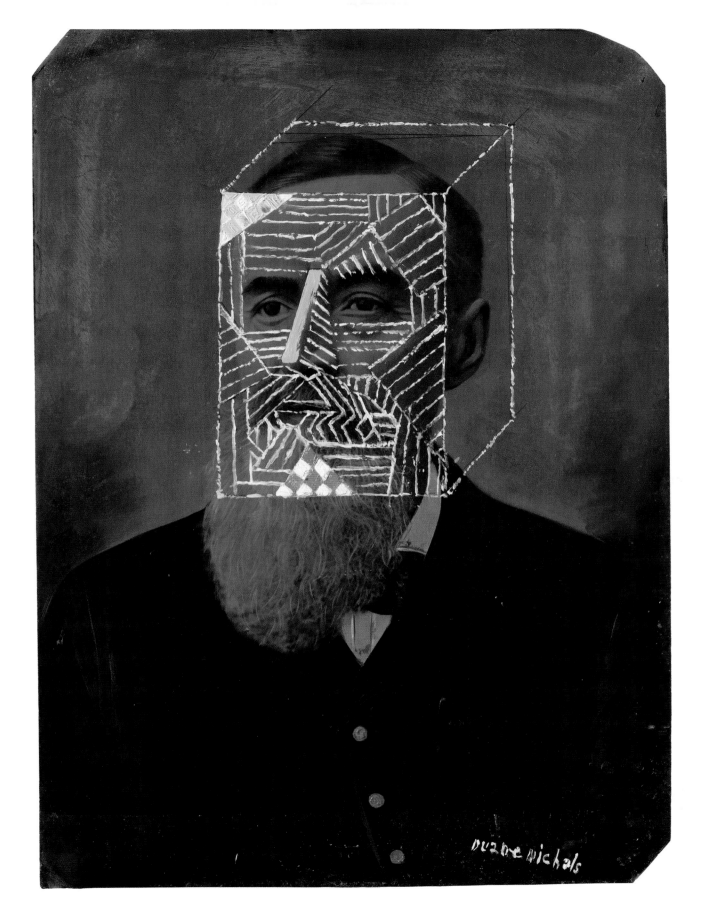

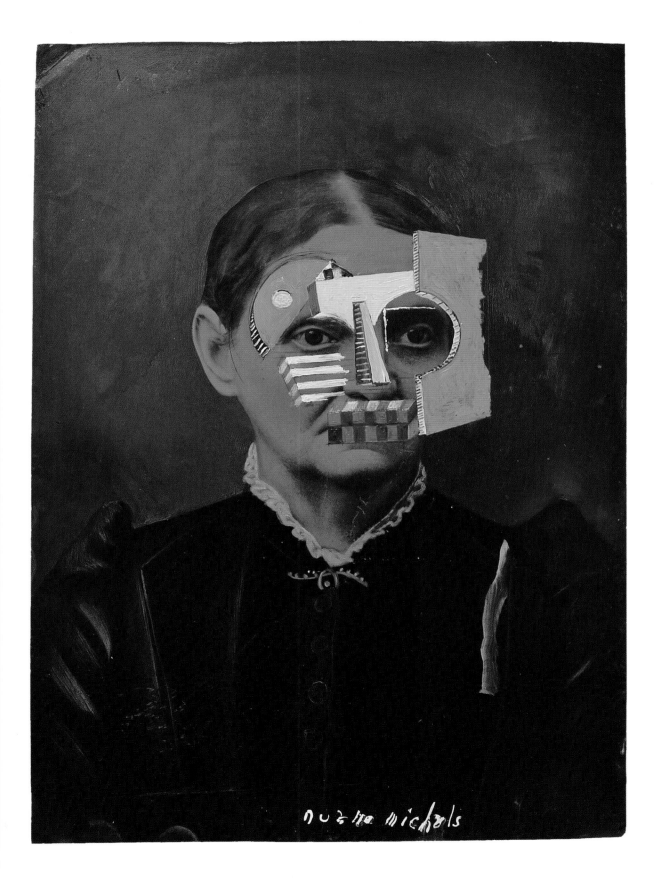

duane michals

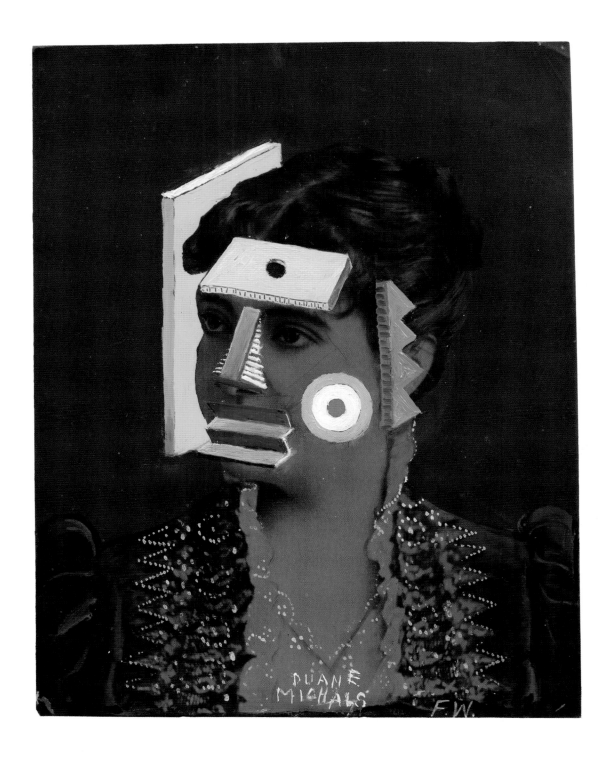

OPPOSITE: *Nora Barnacle*, 2012
ABOVE: *Molly Bloom*, 2012

Kafka

A roach goes to bed at night
and wakes up a human being.
Appalled at the sight of only
two arms and legs,
and a head without antennae,
the roach commits suicide
by stepping on himself.

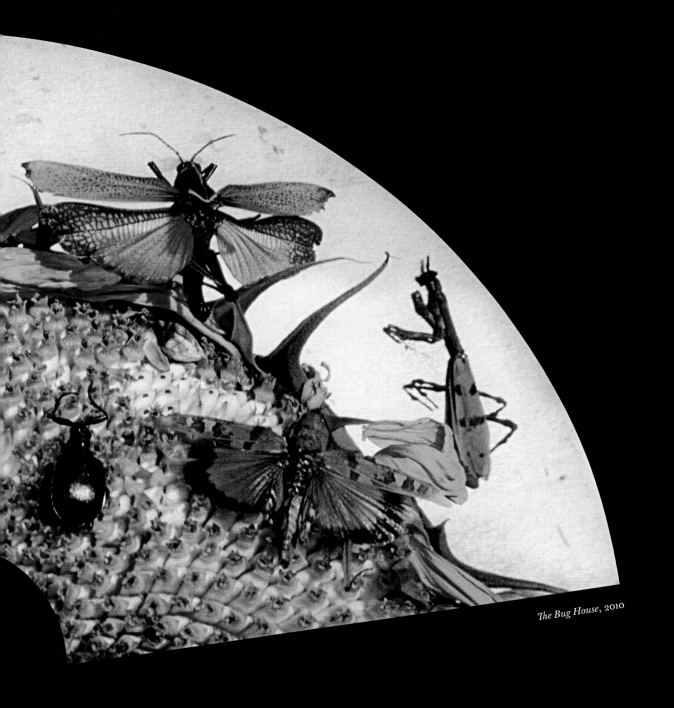

The Bug House, 2010

For many years on West 57th Street, in the building above Geoffrey Beene's atelier, a master photo printer named Igor Bakht had his lab. Igor had famously rescued all of the negatives that Roman Vishniac had hidden in Poland during the war. Among Bakht's other clients were the beauteous Candice Bergen and André Kertész, whose work I had occasionally seen. I was always intrigued by his pictures' consistent elegance. I assumed that he was deceased since all of his pictures had been taken thirty years earlier. In 1964, *Show* magazine published a portfolio of his work, at a time when he was completely invisible in photography circles. The last page of the portfolio reproduced a Kertész made in 1962, which took me by surprise. Upon inquiry, the art director Henry Wolf told me that Kertész was alive and lived on Fifth Avenue and Eighth Street! Fifth Avenue and Eighth Street! I lived on Ninth Street between Fifth and Sixth Avenues!

In time I met Kertész, and the more we met, the more enthralled I was by him. But beneath his affability André was a closet curmudgeon. One never asked him, "André how are you?" His reply would be, "How am I? Terrible!" Although he had at last been lauded universally as the photographic genius he was, Kertész remained irascible and disappointed. When he arrived in America in the early forties, he left behind in Europe a huge reputation. To his dismay, nothing happened for him here. He was not picked up by *Life* magazine, or any publication worthy of his abilities, and he spent years working at *House and Garden* as an obscure in-house photographer. His reputation atrophied. After he retired from Condé Nast, he renewed his private work, and his career blossomed. Now, having been rediscovered, one would think his wounds had healed, but they hadn't.

In Igor Bakht's studio was a sofa reminiscent of one that appears in David Hockney's famous portrait of Henry Geldzahler and Christopher Scott. I thought it might be a private joke to do a self-portrait with Kertész, duplicating the Hockney painting. When I suggested the idea to André, his response was an immediate "No!" André

OPPOSITE:
*Self-portrait with
André Kertész in
the manner of
David Hockney*,
1982

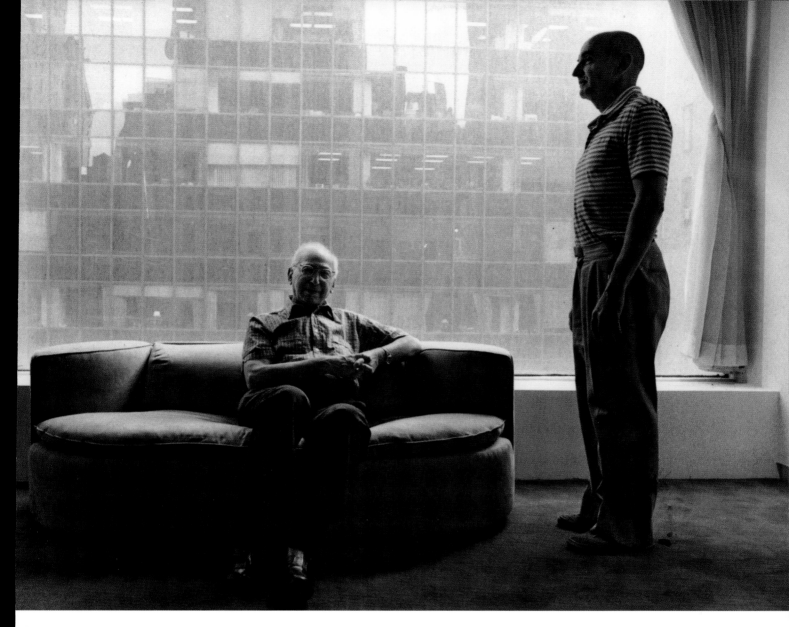

Self-portrait with André Kertész in the manner of David Hockney.

accused Hockney of stealing the idea of photographing men swimming underwater from a photograph that Kertész had taken of a man swimming underwater in Paris. He was indignant for having been ripped off by Hockney. I saved the day by suggesting that now was André's chance to rip off Hockney by duplicating the famous portrait with me as the acolyte. When I saw he was amused, I knew he was delighted by the suggestion, and I felt that I had pulled the splinter from his paw.

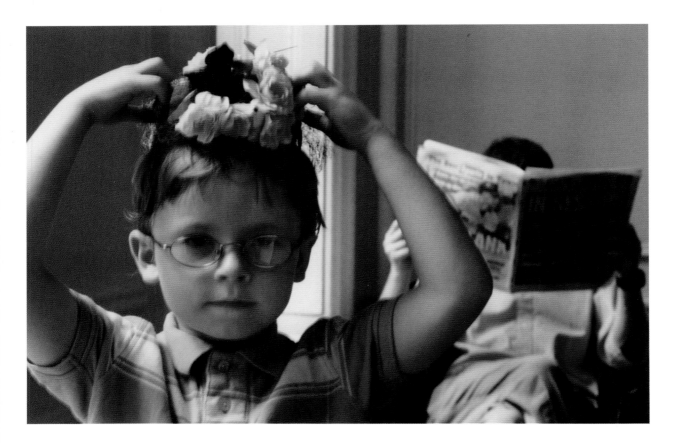

L*adies' Hats*

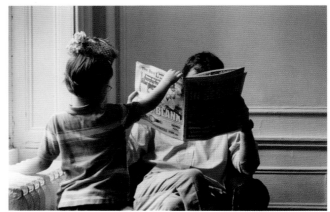

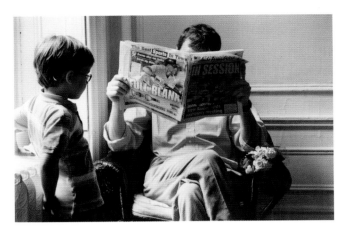

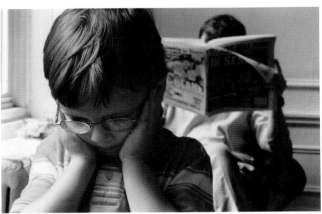

Huntington Hartford, the A&P heir, was profligate with his fortune. Among the many projects that lightened his purse was *Show* magazine. In the 1960s *Show* was the precursor to *Vanity Fair*, a gossipy celebrity-laden show-biz bible. The art director was Henry Wolf, the most celebrated designer of his time. Among the monthly features was one entitled, "Where are they today?" The idea was to revisit celebrities who had lost their fame to see what they were doing now. I was often given the job to photograph them.

Veronica Lake was a huge Paramount star during the Second World War. Her trademark was combing the waves of her long blonde hair alluringly over one eye. It became such a fad that women working in factories who adopted her peek-a-boo look were in danger of getting their hair caught in machinery. Rosie the Riveter was reprimanded for endangering the war effort. In 1962 I had a call from Henry asking me to photograph Veronica Lake for the aforementioned "Where are they today?" feature. When I was 12 years old, in the early 1940s, I had been aware of the glamorous Ms. Lake. I was thrilled at the thought of actually meeting her. Her address was the Martha Washington Hotel, in Manhattan's mid-20s, where she was employed as the hostess in their dining room. When I arrived, this slight, plain-looking woman greeted me, and I was disappointed to find that this was the great actress. To make her seem more successful than she was for the article, the editors decided to pose her as the manager of the hotel. Make-up and hair delivered a respectable looking businesswoman in front of my lens. She sat behind the manager's desk with all of the accoutrements of the job, appearing plausibly managerial, and seemed to maintain a sense of humor. At a break in the photography, the actual manager who stood next me pointed his thumb at her and said, "Can you believe that is Veronica Lake?"

As we made our goodbyes, Ms. Lake asked me if I wouldn't mind photographing her with the two clerks behind the desk. "Sometimes if you don't pay your rent on time they lock you out of your room."

OPPOSITE:
Veronica Lake,
1962

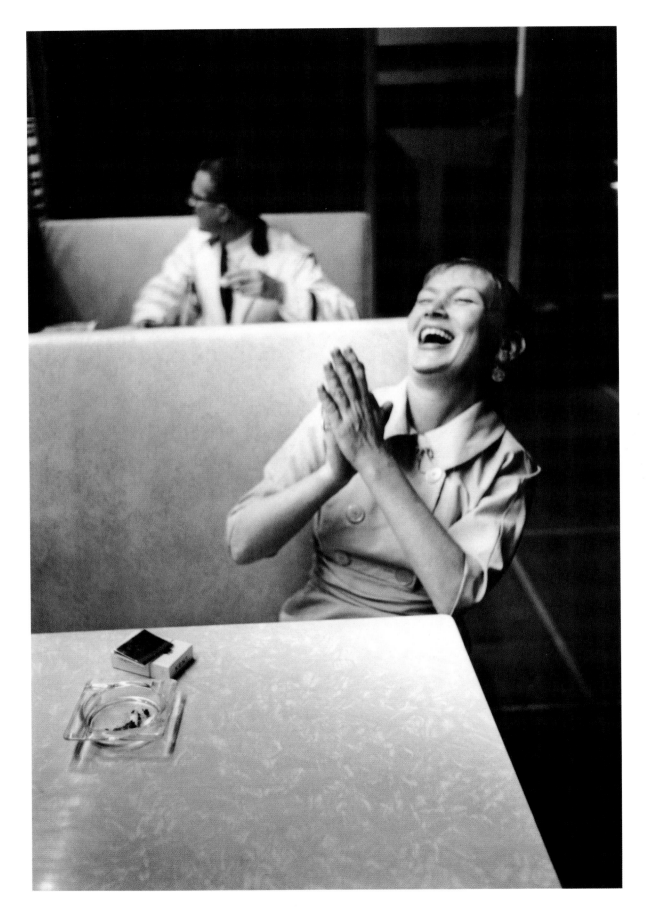

Real Drawde

When he drank beer
that queer Edward Lear
went backwards when he stepped forwards,
and forwards when he stepped backwards.
He had no way of knowing
which way he was going,
cavalier Edward Leer had no peers.

Enaud Slahcim

A giggle, giggle for dear
Edward Lear
Who wrote rhymes without reason,
I hear.

With all rules he dispensed.
He despised common sense
And deemed logic to be
insincere.

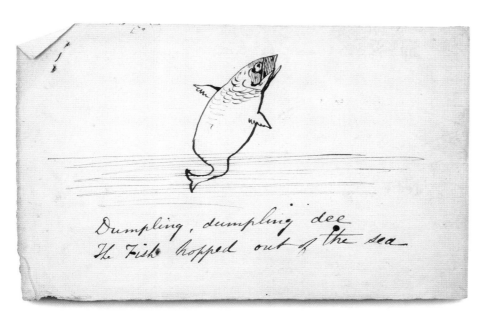

Dumpling, dumpling dee
The Fish hopped out of the sea.

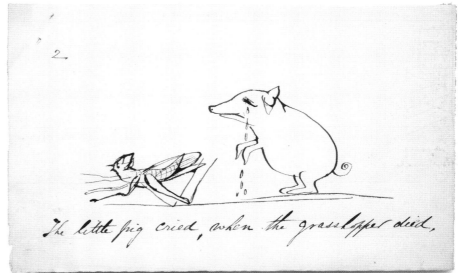

The little pig cried, when the grasshopper died,

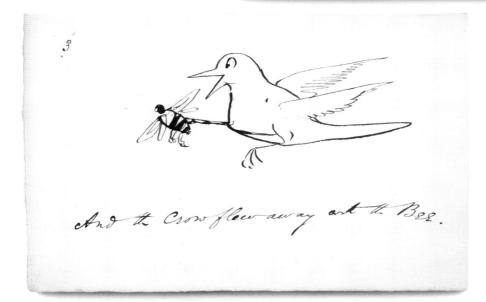

And the Crow flew away with the Bee.

List

How can I explain my great fortune in having wonderful friends? Fritz Gruber, who had been for decades the director of Photokina, the great international photo fair, always was too generous to me. Upon arriving in Cologne in 1975, I was met at the airport by Fritz and his wife Renata. As we drove back, Fritz asked if there was anyone in Germany I would like to photograph. Herbert List, I answered. With a sigh, Fritz replied that List had died that very day. List would have been very happy to meet me, he said, adding that he was sure we would have understood each other.

Herr List had been a guiding light of Surrealist photography in the twenties and thirties in Germany. There was an underlying homoerotic quality in the young men he photographed on the beaches of Greece or with temples and fallen columns as background, and he also made wonderful portraits of Morandi and Anna Magnani, the leading Italian actress. List was relatively unknown in the world of photography because of his particular niche, and he was out of step with the contemporary paradigm of photography as documentation or the notion of a decisive moment. As the heir to Baron Von Gloeden's visual appetites, his work was dismissed as queer self-indulgence, my dear.

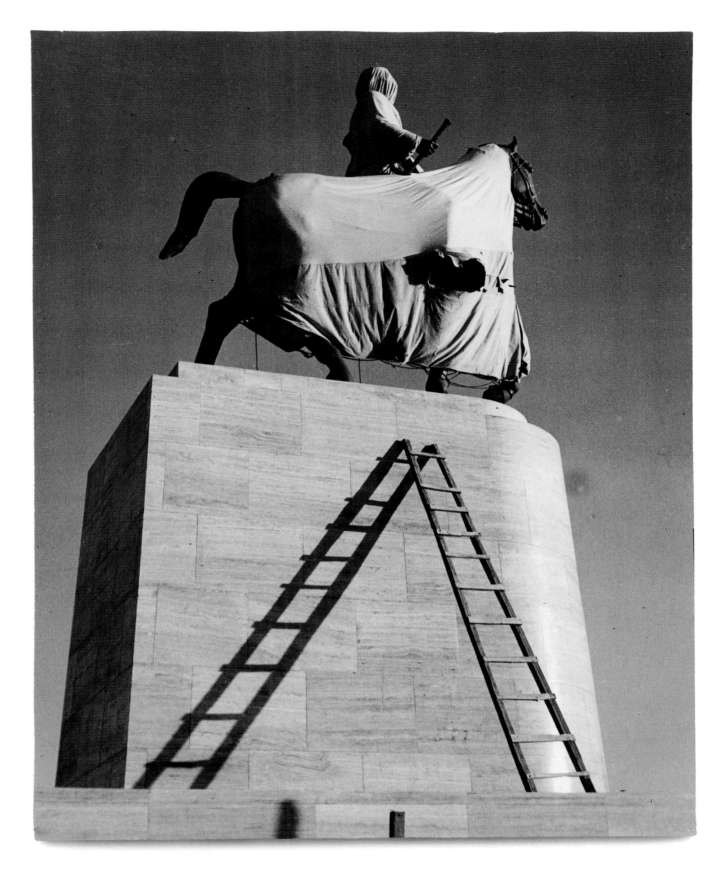

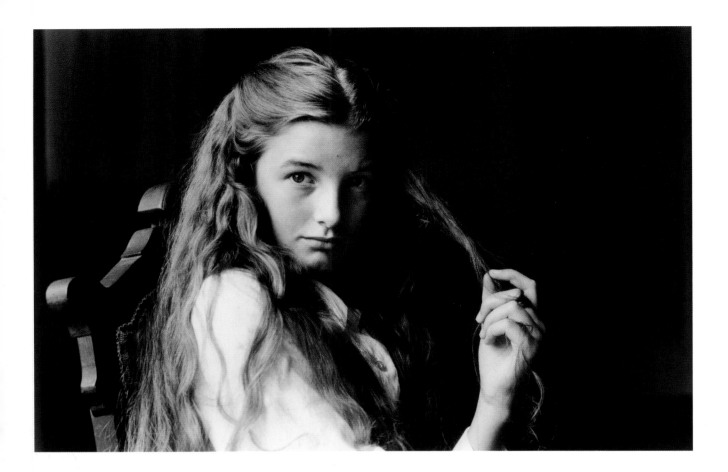

L*olita*

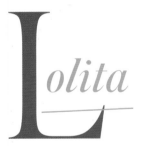

"Lolita, light of my life, fire of my loins. My sin, my soul. Lo-lee-ta: the tip of the tongue taking a trip of three steps down the palate to tap, at three, on the teeth. Lo. Lee. Ta."

Nabokov, light of my flashlight, fire in my furnace. My twin, my Nat King Cole, Na-Bo-Kov: the tip of my bum taking a sit of three minutes to nap, on the seat.

Nab. Whoa. Cough.

The opening lines of *Lolita* are probably the most original erotic sentences in the western canon. The brilliant description of the physical action of the tongue in the mouth as it pronounces her name has erotic implications that innocently titillate, making them perverse. Saying "Lolita" is almost a sexual act itself.

ABOVE: *Lolita*, 1993

Love

Love is a secret that the soul of one shares only with the soul of the other.

Tiny particles of affection fill the air like swirls of snowflakes.

They dance curlicues of delight in this invisible blizzard.

People see the lovers' happiness but do not hear their music or feel the snow
that melts on their smiles. The lovers sway with tenderness.

BELOW: *He Thought She
Was Beautiful*, 1994

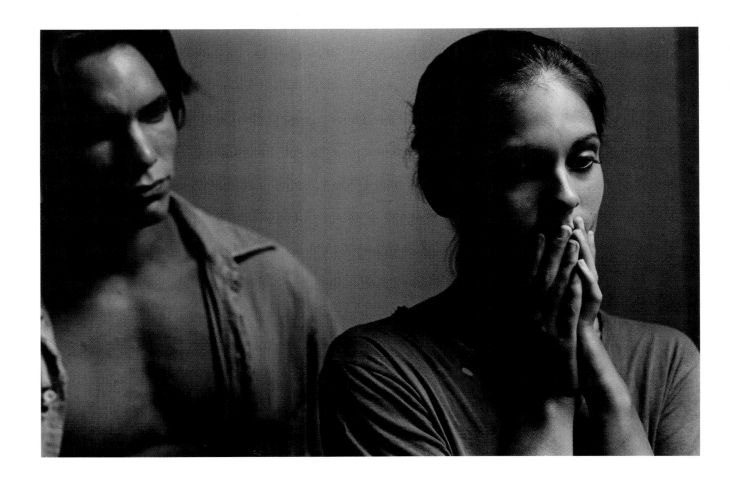

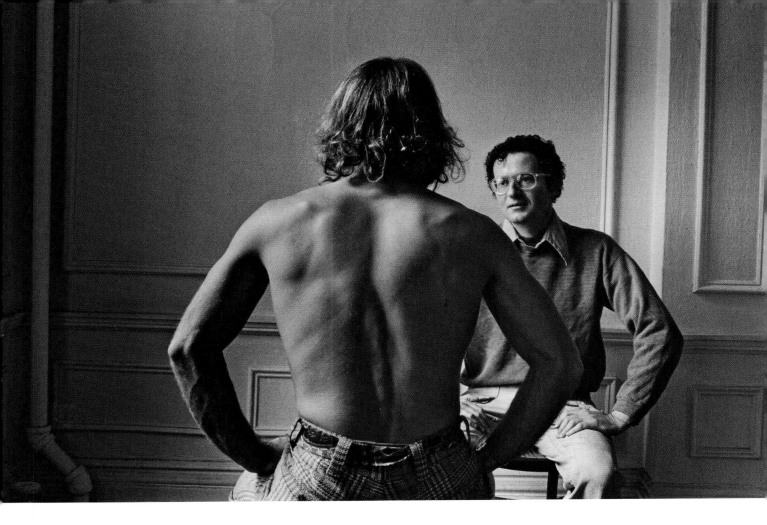

Love (Falling In)

The first time I met you I did not remember you.

The second time I met you, you reminded me that we had met before.

I was embarrassed; you were amused.

Later there was a lingering in my mind of something you had said,
which I now cannot recall.

Quite by accident we sat opposite each other at a dinner. You remarked that
I shaved my moustache. It pleased me to know that you remembered my
moustache, since I never had one. Oh, he has blue eyes, I thought.

Again goodbye, this time with a faint regret.

He suddenly asked for my phone number.

I was taken aback, but also pleased.

When he called he asked for Harry.

I reminded him my name was Henry.

I should have asked him for his number.

Yes, I replied when he suggested meeting for dinner.

When?

Thursday, Union Square Café.

I arrived early, wearing clean underwear.

He was late.

I hoped I was in the wrong restaurant, then it would have
 been my fault, and also it would have been cheaper.

He arrived out of breath, having jumped out of the cab
 to avoid paying the driver.

I was flattered.

The conversation flowed with the wine.

I noticed his pecs, he ordered my man-meat medium rare.

I enjoyed his Freudian slip.

We did not order a dessert.

Who needed dessert?

When he paid the bill, I was falling in love.

In the cab heading toward my apartment he farted.

I was enchanted and began to realize my fate had arrived.

And that is how our romance began.

Magritte

René Magritte,
1965

ABOVE:
René Magritte,
1965

In 1912 Serge Diaghilev invited Jean Cocteau to collaborate on a ballet. Cocteau, the Jacques of all artistic trades, immediately jumped at the opportunity. When he asked Diaghilev what he expected from him, Diaghilev replied, "Astound me!" He did not say bore me, make it big, paint it red, fill it full of hot air. The first time I saw a Magritte painting, I was astounded. It was an illustration in *Harper's Bazaar* of a nude woman holding a mirror in front of her, and in the mirror you could see her reflected at an angle that was altogether impossible. At first I thought this conundrum was a trick photograph, but I was surprised to realize it was a painting, which explained the contradiction.

118

Magritte seldom disappointed. Everything he did engaged my imagination with the dimensions of his genius. He painted a pipe, and underneath wrote, Ceci n'est pas une pipe ("this is not a pipe"), which I assumed erroneously that it was. One would see an easel with a canvas in front of a window, with the view through the window on the canvas. Apples floating miraculously in front of bowler-hatted men. A woman attacked by a man who has entered the silhouette of her body. A bedroom furnished with a giant comb, matchbox, and bar of soap as part of the décor. He would never make large paintings of pure color reminiscent of paint samples. He would never paint American flags or beer cans. And he would never reproduce someone else's photograph of Marilyn Monroe. He transcended the obvious cultural clichés. All authentic artists invent their own mystery; they refuse to regurgitate a public domain vocabulary. One cannot duplicate their uniqueness. When I see a Magritte painting I know that nobody else could have come up with that particular notion, as private as poetry.

RENÉ MAGRITTE, *The Indiscreet Jewels (Les bijoux indiscrets)*, 1963

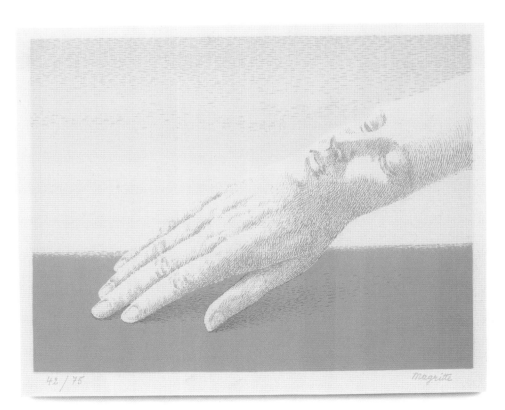

42 / 75 Magritte

M*anet*

Few have noticed that Jan Vermeer was born in 1632, Franz Joseph Haydn in 1732, and Édouard Manet in 1832. I myself was born in 1932.

Am I the only one who sees a pattern?

On a blustery October Sunday in Paris, I was privileged to spend the afternoon with descendants of the Édouard Manet family, photographing their private collection of paintings, drawings, and memorabilia. My great friend Philippe Stoeckel, an immunologist in Paris, arranged for my visit. Everywhere there was something thrilling to see. One of my favorite paintings by Manet is of a little bouquet of violets with a ladies' fan, and they owned it. I could pick it up, look at the back of it, and feel its patina. It may not sound like much, but it was really wonderful. They also owned the great portrait of Berthe Morisot, now in the collection of Musée d'Orsay. But a real treat awaited me when they presented the bracelet that Olympia was wearing on her right arm in the famous painting. How magical that this object was on the forearm of the redhead model, Victorine Meurent. It's as if the bracelet were a witness to that afternoon when Manet labored in his studio, and when I touched it I shared the moment too.

OPPOSITE:
Untitled, 1983

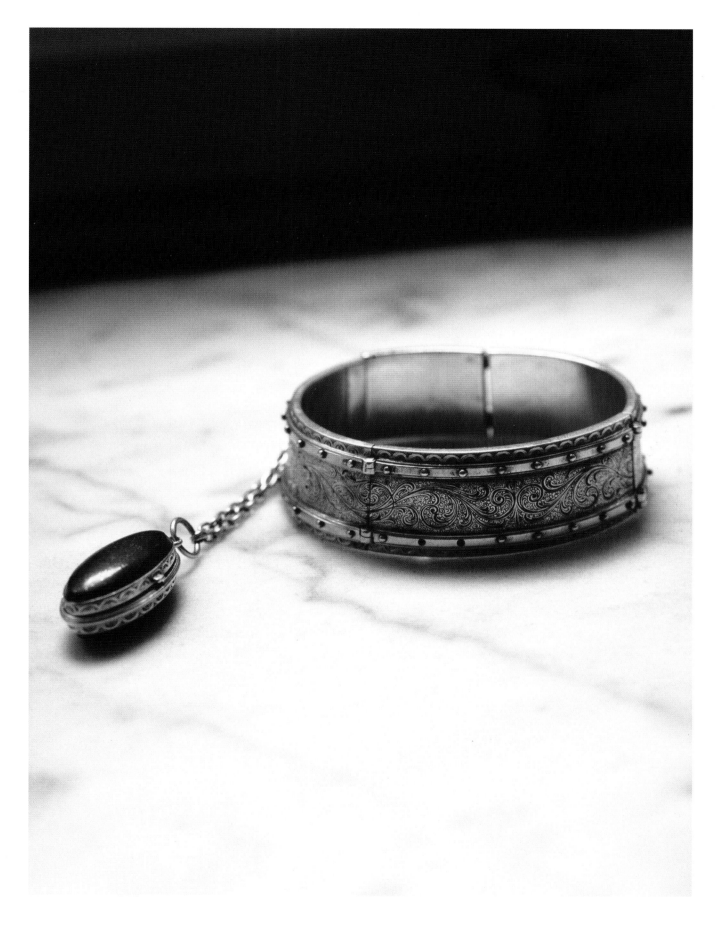

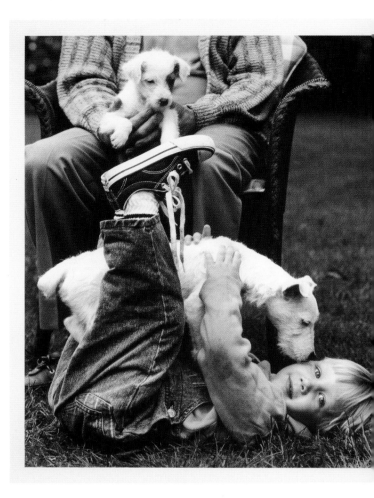

Mass Mutual

I have always made my living as an amateur-professional, with no inclination to set up a studio, hire staff, or buy the necessary equipment to be a big-time commercial success. I functioned comfortably as cottage industry. My ambitions were modest. My idea was to do something that I loved doing, and have somebody pay me to do it. Consequently, I haven't worked in fifty years. Never having gone to photography school was a huge advantage. They have to teach you rules, and unlearning those rules is even more difficult than learning them. Once I was on location, and a young photo student came up to me and asked if I was Duane Michals. When I answered yes, she said, "What are you doing here?" I replied, "Making a living." She responded, "I could never sell out." What she didn't understand was that she had nothing to sell. I have always felt that my private work was never meant to support me. The raison

A promise that puppy kisses are the very best kind. For now, anyway.

A promise to teach you that the more love you give, the more love you get.

A promise that in some way, I'll always be behind you.

Nothing binds us one to the other like a promise kept. For more than 140 years, we've been helping people keep their promises by ensuring we have the financial strength to keep ours. That's why families and businesses rely on us to insure their lives, their health and their financial future.
Life & Disability Insurance ✦ Annuities ✦ Group Life & Health Insurance ✦ Pension & Retirement Products ✦ Investment Management

MassMutual
We help you keep your promises.

© 1996 Massachusetts Mutual Life Insurance Co. Springfield, MA 01111

d'être of my self-expression was to maintain an unfettered freedom to say whatever I wished.

I've always enjoyed making money. Not too much, not too little, just enough. The great variety of clients I had would surprise many, as my name did not usually appear as a credit. I feel proud that I could function in both the art world and the commercial world with success, and I do not look down on advertising work. Originally I did mostly editorial photography, which appeared in almost all of the major magazines. Years later I discovered the financial rewards of commercial advertising and constantly amazed myself that I could actually do it, having served no apprenticeship and having learned everything on the job. In the crush of the New York advertising business, you are only as good as your last ad, and there are no return engagements if you disappoint.

One of my clients was Mass Mutual Life Insurance, for whom I did a campaign that lasted nine years. The idea was to show the relationships between grandparents and children. I soon learned that working with children younger than three years old was a nightmare. On all shoots we would have three or four toddlers on hand to substitute for a bored, crying kid. For one ad I had to photograph a grandfather, his grandson, and two puppies—a volatile mix certain to cause panic-inducing anxiety. The dogs would not listen to a command, the children were worse than the dogs, and the grandfather fell asleep. Miraculously, it somehow came together when I substituted the dog trainer's son, who was familiar with the animals, for the booked model who was terrified of dogs, and woof! woof! Happy ending. A few days later I came down with anxiety-induced shingles, the price of my perfection.

M*orandi*

Should you mention the name Giorgio Morandi to someone and they respond, "Oh, the guy who paints the bottles," you can be sure that he hasn't really looked at a Morandi. Morandi does in fact paint bottles, but that's like saying, "Oh, van Gogh, the guy who paints sunflowers." Morandi is an acquired taste; the subtle variation of colors in his limited palette invite a meditative attention. Critics often toss around the phrase "so-and-so is an obsessive painter," for example, the Warhol who repeats ad nauseum a stencil of an electric chair. A true obsession can never be satisfied, because the deeper one gets into the subject the harder it is to extricate oneself. With a minimum of means, a series of bottles and cans, Morandi plays a rondo, finding infinite variations on that theme. It is demanding work, easily dismissed by sensation seekers.

I can't remember the year, but long ago I had an exhibit in London at Hamiltons Gallery, which was reviewed by a young Italian woman for a Milanese art magazine.

In passing, we talked about Morandi, and as it turned out, one of her professors had been a close friend of his. I had always been intrigued by Morandi's studio, which was still extant in its original location.

If I couldn't photograph Morandi himself, perhaps I could photograph his studio. To gain entry, we had a letter of introduction from my Italian writer's professor, but he insisted we visit his apartment in Milan first.

We rendezvoused in Milan and went to a wonderful 1930s Mussolini-modern apartment house. His apartment was the essence of time and history.

The rooms had tall ceilings and large windows, and there was a clutter of books, manuscripts, paintings, and drawings. I suppose he wanted to meet me to make sure I wasn't some rogue paparazzo. He said that when I would be in Morandi's studio, I should look out the window into the courtyard behind, and there would be a very large tree. He and Morandi had planted the sapling together, and now it would outlive both of them.

Bologna is a city of arcades and passages and is famous for its cuisine. Morandi and his three sisters, Anna, Dina, and Maria Teresa, had shared an apartment together for their entire lives. By this point, two of the sisters had died, but the remaining one had generously agreed to take us to the studio, which was at another location. A gray-haired old lady wearing black, she was very patient with us two intruders, and as we walked from her apartment to the studio, she casually mentioned that she hoped it was still there. I casually turned white. The studio was a room Morandi rented in his landlord's apartment, and she hadn't been there recently. She was not quite sure it hadn't become a storeroom for old luggage and washing machines.

———

Giorgio Morandi's Studio, 1985

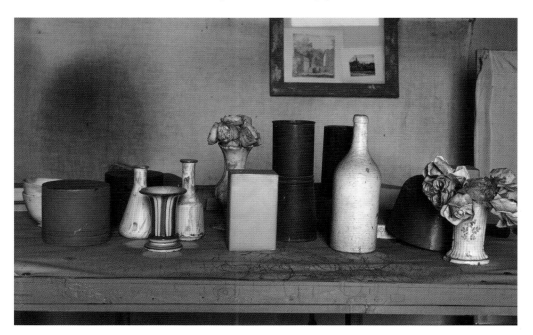

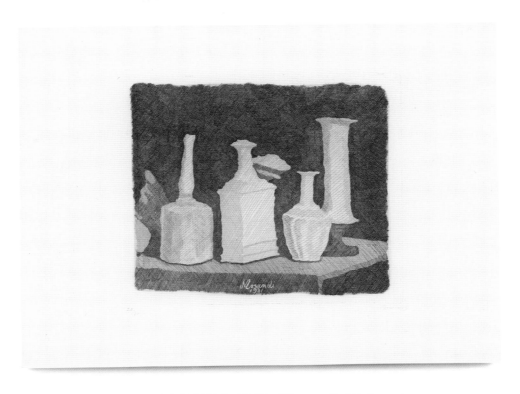

GIORGIO MORANDI, *Still Life with White Objects on a Dark Background*
(Natura morta con oggetti bianchi su fondo scuro), 1931

———

We opened the door, and there were tables with arrays of bottles, all recognizable to me as subjects of his paintings. Against one wall was a lounge where he napped every afternoon, and above it were some framed Morandi prints hanging at odd angles. Opposite that was another table with a setup of three objects, for his last painting. I was disappointed. Through a large window in the other wall the tree that the old professor had described was gone. Along a fourth wall were a series of stands cluttered with dusty bottles and vases. The light from the window was that gentle Morandi haze, soft and velvety, that caresses. Morandi's sister said I had half an hour to work, and in my rush to photograph I went into panic mode, accidently knocking over my tripod and misplacing my light meter. She kindly said, "Don't rush, take as much time as you need," and I did.

When people live in a space for a long time, I think their presence still inhabits the room long after they've departed. It's as if a certain scent has imprinted itself in the atmosphere. I could imagine him taking his afternoon nap in that lounge, drifting to sleep in the silence of his own paintings.

Ralph Vaughan Williams, "The Lark Ascending"

With synapses singing,
And spirals wending
twirling in the sky,
A Chinese dream
Of larks' ascending,
I close my eyes and sigh.

Josef Suk, "Scherzo Fantastique"

I tripped the light fantastique,
Waves and particles of delight,
I skipped from cloud to cloud,
And disappeared out of sight.

M*usic*

On Wings of Music

Babes lullabied with love, rhythms of desire, Ring of Fire, the
crescendo of choirs, Puttin' on the Ritz, the stoned Stones, Cage's
chance, the tip tap toe and grande jeté, swing and sway and dance,
Chopin nocturnes, John Philip Sousa strutting into the spheres,
being touched to tears, our song, tra la, tra la, tra la.

OPPOSITE:
Arcimboldo,
2009

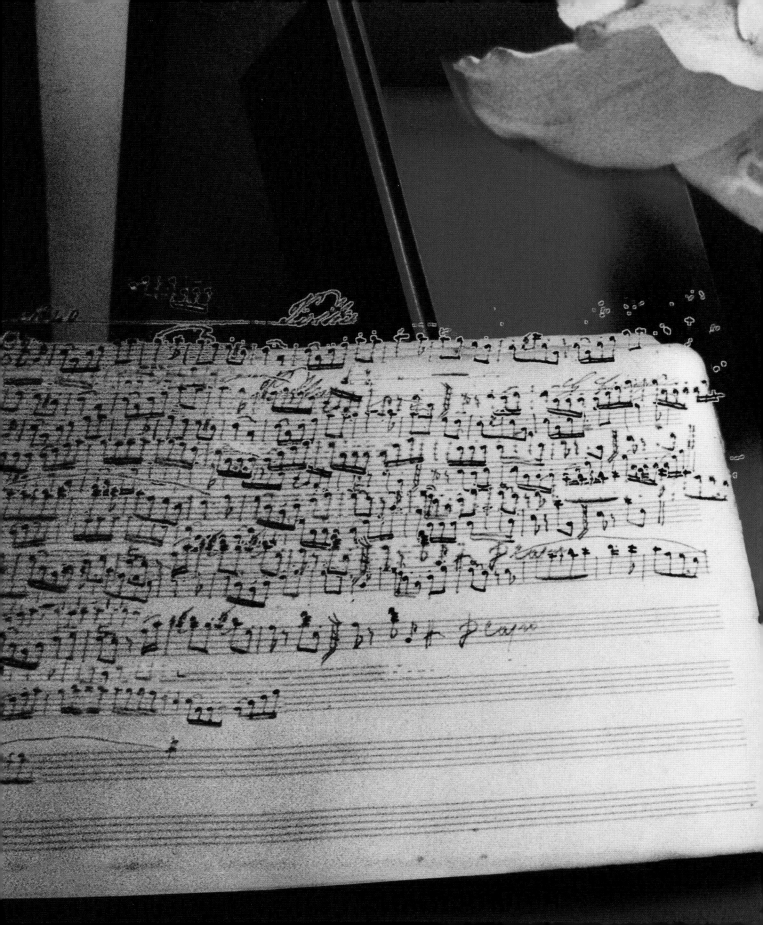

N*ietzsche*

Thus Sprach Duane:

In the middle of February 1944, every morning at 6 AM a sleepy Sonny would get up from a cozy warm bed in a freezing house, quickly dress, step out onto a snowy porch, and head down the hill to pick up his *Pittsburgh Post-Gazettes*. Half asleep, almost by rote, he would find himself at the newspaper office loading his heavy delivery bag with the day's journals. He felt warm for ten minutes.

Up Sixth Avenue he would trudge, past Johnson the Florist, to Shaw Avenue, with the snow melting on his neck, then down twenty steps to Fifth Avenue, only to be greeted by a blast of icy wind. Then all the way down to Klein's Men's Clothing store, left past the gates of National Tube, and up Lylse Boulevard to home. By then the coal stove in the kitchen was going and mother would have breakfast ready, just in time to make school by 9 o'clock. Sometimes there would be donuts from Zotte's Bakery.

Sonny was twelve years old. The last thing in the world he wanted to do was to leave his toasty nest and drag himself into wakefulness for the shivering pleasure of delivering daily newspapers. It took all his will to face the frigid wind. Somehow, in spite of all the discomfort, he managed to get up and face frozen McKeesport. This simple act of minor courage is what I always envisioned that Nietzsche had in mind when he defined the Übermensch. The superior man accomplishes difficult things by exercising his will. Without the strength to override the adversities of our lives we will always remain somehow less than our potential. Sometimes the smallest problem can demand a huge amount of heart.

OPPOSITE:
LEWIS WICKES HINE,
Two Seven-Year-Old Nashville Newsies, Profane and Smart, Selling Sunday, 1910

The following is the opening scene from Ermanno Olmi's movie *The Fiancés* (*I fidanzati*, 1963). A simple film that beautifully touched me.

The screen is black. The sound of footsteps is heard. A light switch is flicked on, revealing a large empty room with chairs around it. A man enters carrying a trumpet case, walks across the room to the first man who is tuning his violin. Little by little, they are joined by more members of an orchestra. More light switches are turned on, illuminating a provincial Italian dance hall.

Now the patrons arrive, wearing old-fashioned 1955 wardrobes. The room begins to fill with couples sitting at tables, engaged in conversation, smiling, ordering drinks. The orchestra begins playing an American fox-trot. First one brave couple gets up to dance, and soon they're followed by others. As the camera pans around the room it settles at a table with two bored patrons staring at nothing in particular. These are the fiancés, who have been engaged for twelve years. Every Saturday they go to the dance and sit at the same table, with diminishing return, their conversation becoming more and more about silence. They are like an old married couple who never married.

The young man receives a promotion at work. He is sent to Sicily by his company, and although they both appear to be saddened by his departure, they are secretly pleased. They could never break up. They did not have the courage to break off their engagement and were relieved by this fortuitous event. As the young man settles into his job in Palermo, he notices that he misses his Saturday dance dates, and his Sunday afternoons alone in the park seem empty. Eating alone, she misses cooking his spaghetti dinner on Friday nights. Their correspondence grows, and through their letters, they feel something that they had not felt for each other in a long time. They miss each other and fall in love all over again. It takes a separation to bring them together.

This small film got very little attention. No one is killed, no one is shot, no buildings are blown up, there is no nudity, no vampires, only the subtlety of love revealed. SALUT.

Pinter

The Thimble

BY DUANE MICHALS IN THE MANNER OF HAROLD PINTER:

A middle-class middle aged English couple sits at a small kitchen table. He's reading the paper and she's drinking a cup of tea. The room is illuminated by a ceiling light, which throws hard shadows around the table. Both are self-involved and looking in different directions.

ABOVE: *Paul Hill's Little Room*, 1986

SHE "My tea is cold."

He pretends not to hear.

SHE (louder) "My tea is cold."

He still ignores her.

> *pause*

HE (finally) "Yes?"

They are silent, and the only sound is of him crinkling the pages of his paper.

SHE "Is there anybody in the obituary we know?"

> *pause*

HE "I'll look . . . Oh, Sybil died."

SHE "Dead?"

HE "Yes, dead."

> *pause*

SHE "Didn't you fuck Sybil once?"

> *pause*

HE "Quite right."

SHE "You know I knew. Was she good?"

> *pause*

HE "Cook?"

SHE "No, was she a good lay?"

HE "Rather."

> *pause*

SHE "Cyril shagged me."

HE "Sybil's husband?"

> *pause*

"Really? Oh yes, now I remember. Was he good?"

SHE "Small."

HE "How small?"

SHE "Thimble."

HE "Is your tea still cold?"

SHE "Yes."

HE "Oh."

He gets up and pours her a cup of hot tea.

HE "How much milk would you like?"

SHE "A thimble."

> *End*

Leo Lerman was a prescient editor, a wunderkind of sorts, who never went to college, knew everybody, and attended every party. Marlene Dietrich was a very close friend of his. At twenty-one he was features editor of *Harper's Bazaar*, wrote a book about Leonardo at age twenty six, Michelangelo at twenty-eight, and was senior editor of *Playbill* for thirty-two years. Ultimately he became a fixture at Condé Nast. He had a great capacity for friendship and networking.

I worked with Leo for many years, beginning at *Mademoiselle*. He was always wonderful because of his huge appetite for everything. He was capable of great generosity and encouraged many young people in their careers. I remember distinctly a phone call from Leo, who said something new was happening in the art world. He thought we should investigate. That something turned out to be Pop Art. He suggested we should do a series of portraits of this fledgling group, among them Andy Warhol, Tom

Pop Art

Wesselmann, James Rosenquist, Jim Dine, and Roy Lichtenstein. I was surprised that Andy was on the list, and when I visited his studio, he was in a room full of Campbell's Soup can paintings, wearing black, surrounded by the din of rock and roll. Andy went from showing his decorative gold celebrity boot drawings at the Bodley Gallery to becoming a rock star wannabe. He was curious to know what other painters were on my list to be photographed, and he wondered what their paintings looked like. I mentioned photographing Tom Wesselmann in his little apartment on Bleecker Street, drinking a cup of coffee. I felt since they were dealing with ordinary objects, doing something ordinary was appropriate. The great American nude and still lifes made of grocery products were the subjects of his early collages. I had never heard of Jim Dine and thought his hanging a hammer by a length of twine on a canvas was art-school desperate. I recalled originally seeing Rosenquist's very large close-ups of objects from Bonwit Teller's windows. Rosenquist had been a billboard sign painter and could render a ten-foot pack of cigarettes with one hand tied behind him. I met Lichtenstein at Castelli's gallery and thought the Ben-day paintings of cartoon comic strips a novelty item, but a logical appropriation, given the Zeitgeist. I always considered Pop Art to be popcorn.

OPPOSITE:
Andy Warhol,
1962

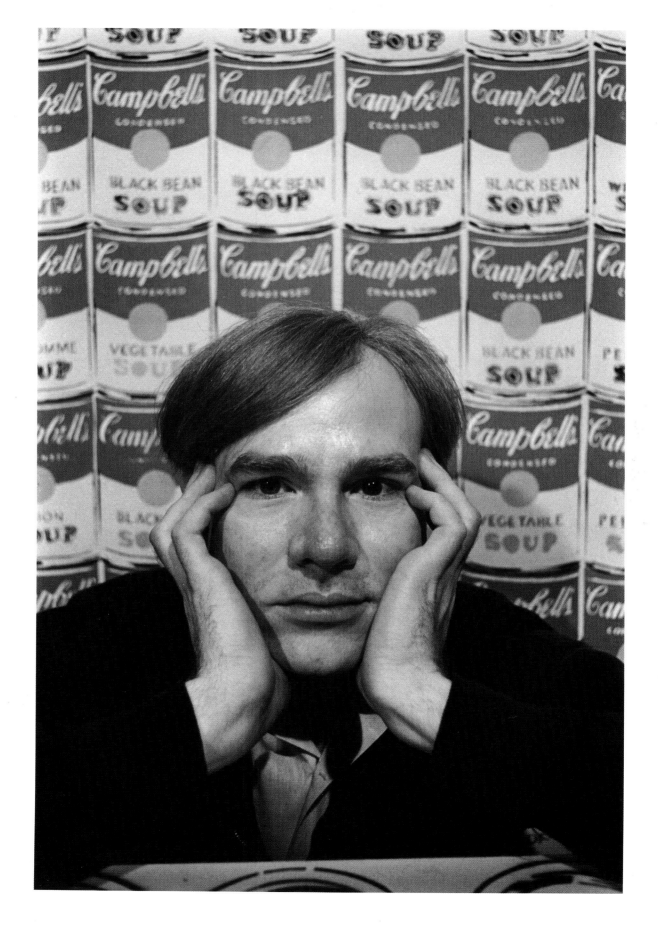

ABOVE: James Rosenquist, 1962
RIGHT: Jim Dine, 1962

ABOVE: *Tom Wesselmann*, 1962 · BELOW: *Roy Lichtenstein*, 1962

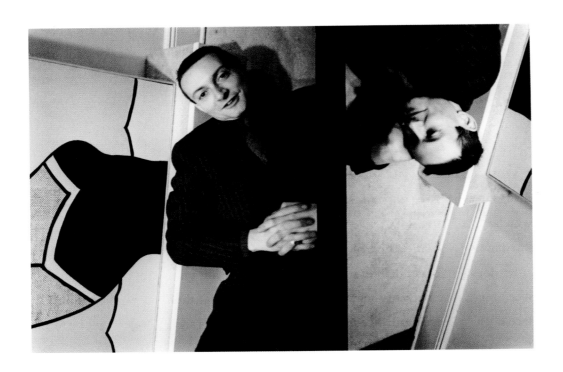

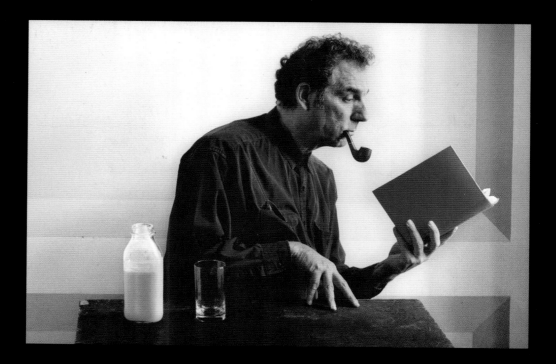

Prose Portrait

I don't believe portraits. Portraits describe the geography of the sitter's face but seldom reveal anything more significant than the size of their nose or the color of their eyes. People are not what they appear to be. How can a portrait reveal anything significant about someone who doesn't know who they are?

The camera reproduces appearances with exquisite fidelity, but it does not bring insight beyond the mask. The greatest scoundrels can appear benevolent and smiling, facades of appearances depend on vanity for their approval. The real value lies in time, when portraits become relics of our history, reminding us of who we once were.

I would like to introduce the prose portrait, a new concept of portraiture that does not necessarily reproduce a person's appearance line for line. The photographer brings insight to the portrait when he suggests the atmosphere of the sitter's identity, which is the sum total of who they are, not just their physical appearance. A prose portrait might require three or four photographs to reveal something about what the sitter does in life that defines him or her. Why do we always photograph somebody's face? Might the back of their head or a shadow hint at their personality as well? A face does not necessarily need to be seen; most people's significance won't be found there. Who cares what Kafka looked like?

PAGES 140–43:
*Monsieur Hulot drinks
a glass of milk*, 2010

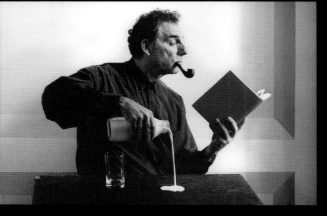

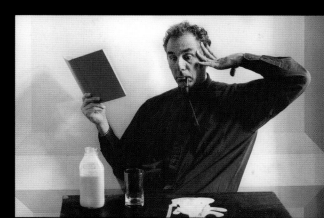

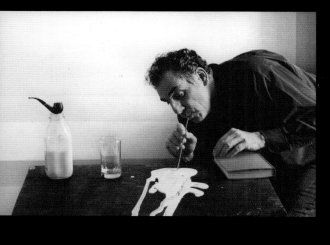

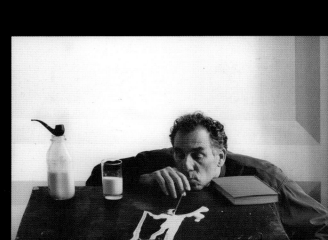

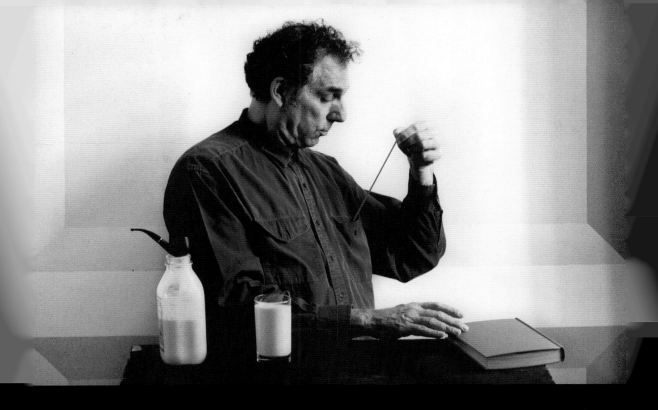

I know what my mother and father looked like, but I have no idea who they were. I picture the two of them standing next to each other, smiling bravely for the camera, revealing nothing. The fact that they had not kissed each other in years, that he drank too much, and that they only shared a marriage, would never be seen in their smiling facades.

This concept demands that the photographer understand the subject and the nature of the subject's work and life. Arnold Newman comes close to this ideal by using props relevant to the sitter's career. The sheer architecture of the way Annie Leibovitz photographs her celebrity puff pieces. Diane Arbus and Joel Witkin belong in this company because of their taste for outsiders and bizarre individuals whose appearance speaks for them.

Each sitter demands a different solution. If the photographer's signature style is so large that it overwhelms the identity of the subject, then the portrait becomes more of a statement of the photographer's brand and does a disservice to its subject. To be successful, there must be a balance between the photographer's vision and

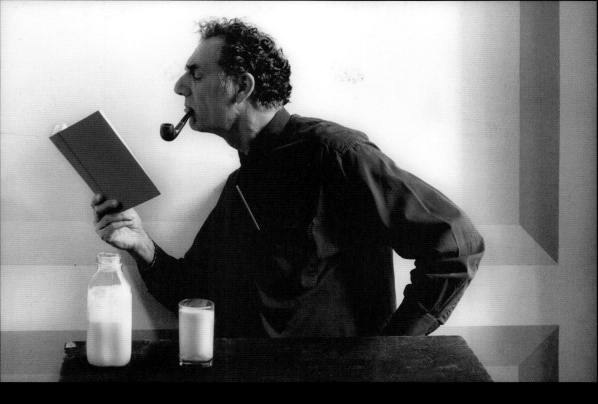

Now digital photography has brought, along with instant gratification, a flood of portraits. The problem has been exacerbated exponentially. Still, amateur point-and-shoot portraits are more authentic in their simplicity than those of the art world. In that world's rarefied atmosphere of "you just don't get it" pretension, the most ordinary photograph can become bloated with emperor's new clothes significance.

Stand and Stare has always been the easy solution to the problem of what a portrait should be. At first, because of long exposures, it was the only way to take a portrait. When blurs occurred, they were considered a failure, although these mistakes might hint at a deeper mystery of the sitter's personality. Today the stand and stare aesthetic has dissipated to the point that the most banal "artists" are critically acclaimed. Rineke Dijkstra is the most overpraised artist of the moment. The Museum of Modern Art pairing her scrawny bather with Cézanne's glorious *The Bather* was an embarrassment.

The prose portrait may not be appropriate for everybody, but when it does work, it inexplicably succeeds at sharing a feeling about the subject, not just about his visage. Photography is by nature conservative; if it doesn't evolve, it will become calcified and remain a minor art.

Qualters

Pittsburgh as Muse

Certain places cast a spell that enchants certain artists. Picture Gauguin without Tahiti, van Gogh without Arles, or Cézanne without Mont Sainte-Victoire. These mythical Shangri-Las fuel the artist's imagination and inspire him. In Pittsburgh there is an eighty-year-old artist named Robert Qualters who has devoted his imagination to the city of his passion. Pittsburgh is his muse. He is unique, not part of a movement manufactured by the art market. It took a lot of courage to become Mr. Qualters without the support system of the New York hullabaloo. It's a solitary adventure. In his romance with Pittsburgh, I imagine him waiting for a bus on the corner of Smithfield and the Champs-Elysées. Out his window, coal barges float down the Mon like gondolas in the Grand Canal. Heinz Field is his new Coliseum.

Although he studied with Diebenkorn in LA, and taught in New York, Mr. Qualters had come full circle to find that the city he left behind was his destiny. Look at his application of paint to the canvas and you will see the subtle influence of Bonnard, and in his rainy streets a hint of Hiroshige. How nice to recognize the authenticity of his dreams of the city of Pittsburgh.

OPPOSITE:
ROBERT QUALTERS,
Edward Hopper
Was Driving,
1997

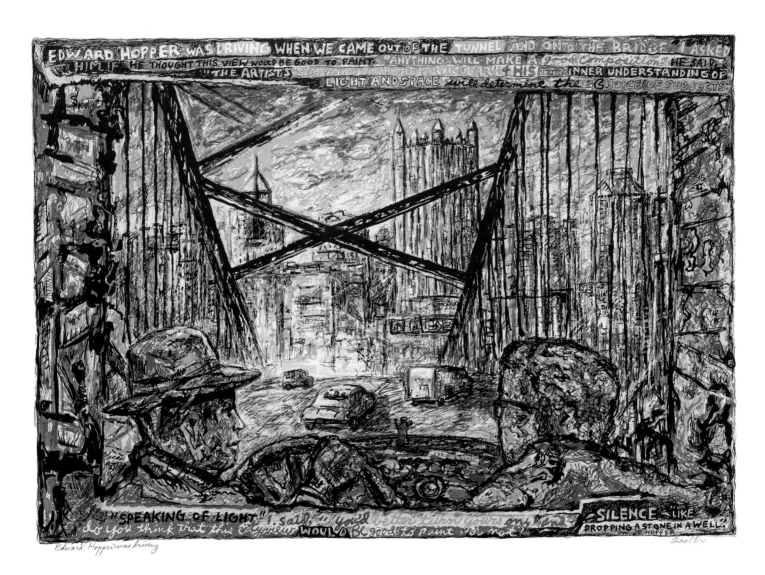

EDWARD HOPPER WAS DRIVING WHEN WE CAME OUT OF THE TUNNEL AND ONTO THE BRIDGE I ASKED HIM IF HE THOUGHT THIS VIEW WOULD BE GOOD TO PAINT. "ANYTHING WILL MAKE A Great Composition" HE SAID "THE ARTIST'S SYMPATHY WITH HIS PARTICULAR THIS IS HIS, INNER UNDERSTANDING OF LIGHT AND SPACE will determine the CHOICE OF SUBJECTS."

"SPEAKING OF LIGHT" I said "you'd better turn yours on" do you think that this cityview WOULD BE good to paint, or not? SILENCE, LIKE DROPPING A STONE IN A WELL. E. HOPPER

Edward Hopper was driving Zaal tow

Quixote

Trudging briskly through an abandoned field, an old man wearing an army fatigue jacket, with the phrase "Hell on wheels" on its back, carries a long skinny branch of a tree as a walking stick. Keeping up with him is a young woman wearing a tee-shirt inscribed "up yours," torn jeans, frizzy hair, and sunglasses. Their destination is an abandoned steel mill. At a distance the rusted open hearths, giant chimneys, and large grotesque shapes look like a scary city from a Stephen King scenario. To their left is the Monongahela River and the city of Homestead, ten miles south of Pittsburgh. As they approach their stride turns into a trot, then a sprint.

The old man is Duane Don Quixote, a veteran of the Korean War, with an alternate vision of reality. The young woman is Tanya Panza, his devoted squire, who shares his alternate vision of reality, and his weed.

Suddenly the old man looks back, shouting, "Avanti, Avanti!" to urge Tanya forward. "Look, Tanya, it's the castle of the king of Carnegie, and his henchman the evil Frick. We must attack and free the serf workers from their indentured prison! Avanti! Avanti!"

Then in a burst of excitement he begins to sing the following ditty to the tune of *The Man of La Mancha*:

I'm Duane Don Quixote,

The man from McKeesport,

I come here to free all the serfs

I'm Duane Don Quixote,

The man from McKeesport,

I'll break up the cap·i·tal·ist curse

Entering the hulk of the haunted mill, Duane Don Quixote shouts, "Come out you coward Carnegie!" Then turning to Tanya he cries joyfully, "Tanya, they fled, the coward Carnegie has abandoned his castle. The workers have triumphed, goodness will reign, and everyone will live happily ever after." Then, delighted and exhausted, Duane Don Quixote drops dead.

OPPOSITE:
I Remember Pittsburgh,
1982

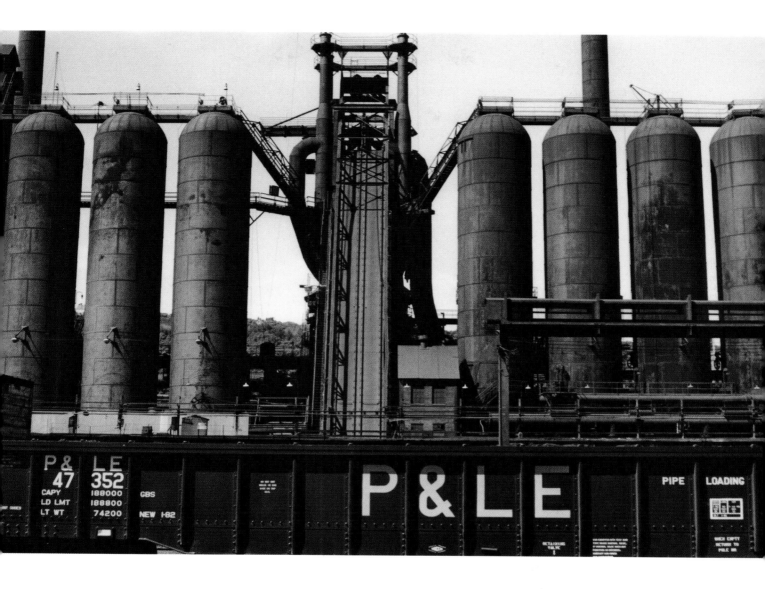

The delusional Duane Don Quixote discovers an old
abandoned steel mill on the banks of the Monongahela River near
Homestead, Penna., and they charge the castle singing the
stirring anthem at left.

imbaud

Rimbaud wrote the most amazing non sequiturs.
To Rimbaud, in the manner of Rimbaud.

Dwarfs cavort, steeples, zephyrs wave the banners.

Water falls with jewels gleaming in the cascade.

The swimmer drowns like Lucy with diamonds in her mouth.

Sirens whispering their come-hithers in the dusk.

The touch slumbering on my shoulder.

For Helen a thousand warriors swim upstream to Troy.

A vampire lingers at my neck feasting.

I am embarrassed by my desire for you, Zeus should know better.

I see myself reflected in your reflection, you wink.

Good oh for you, a bad cloud waves goodbye.

Zut alors, a crow watches me walk backwards.

Is it still today?

OPPOSITE:
Portrait of Rimbaud,
2013

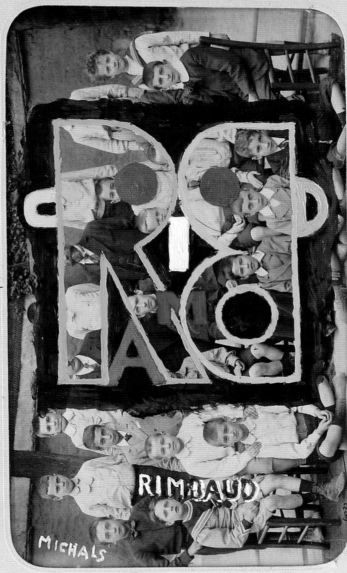

Classe de Septième.

MICHALS

RIMBAUD

ECOLE BOSSUET, 1907-1908

M. Comby — J. Bégambel — R. Juilliand — P. Bouchot — M. POINLOT (?) — Marcel d'Hélaux — P. Werckhan — Guy de Bonneval
Kanem. Krantikintzig — M. Imbs — R. Crevel — C. Burand — L. Cazemarie
B. Vendel — P. Mory — M. Phinson — M. GUESDON (?) — L. de Lagatie — P. Sublleau — R. Cludi
P. de Lagatie — H. Legendre — M. Bouchet

Has something ever happened to you that changed your life? Going to Russia in 1958 changed mine. That year I was a prole working at Time Inc. in the advertising department for *Sport Illustrated* et. al. As a graphic designer I wasn't brilliant, but I was good enough to manage an entry-level career. I had always had an aesthetic itch, but I didn't know where to scratch. Because I love books, I came to New York to find a job in publishing and finally arrived at Rockefeller Center. I had just turned 26 with two years in the army and four years in Colorado behind me. Look out world, here I come!

Although we were not talking to the Russians in 1958, and the Cold War was frigid, I discovered it was possible to go to Russia on an Intourist tour. Unfortunately the price tag was $1,000. That was a lot of money since I was making $5,000 a year. I borrowed $500 from my mother and father, and saved up another $500 by eating

sandwiches for dinner. Before I could say "Comrade Stalin," I was in Helsinki with a borrowed Argus C3 camera in my luggage and vaguely apprehensive that I might have made a mistake. Up to that point I had taken a small useless photography course during the one year I attended Parsons. It seemed appropriate that I would take photographs, since that's what tourists do. It was recommended that I buy Tri-X film, but I refused to take a light meter, as it would label me as a professional. Being a professional was intimidating. Irving Penn was a professional.

My plane arrived in Helsinki that Friday night an hour late, which caused me to miss the last train to Leningrad and forced me to stay in Finland over the weekend.

———

Boy in Leningrad, 1958

When I did arrive in Leningrad at midnight Sunday, I was thrilled. Everything looked like a Dietrich and von Sternberg film set with dark ominous boulevards that led me to a 1925-vintage, exhausted grand hotel. And I was off. In Leningrad I soon learned how to say, "May I take your picture?" in Russian, "Могу ли я считать свою фотографию," and I began to stop strangers, who found me a curiosity. Soon I was on my way to Kiev, after a brief stop in Minsk, and four nights later an overnight train from Kiev deposited me in the central station of Moscow.

The trip was more exciting than I had imagined. I thrived on the novelty, the strange architecture, the shabbiness of the cities, the unsmiling people, the terrible

ABOVE: *Soldier in Red Square*, 1958 · OPPOSITE: *Children in Leningrad*, 1958

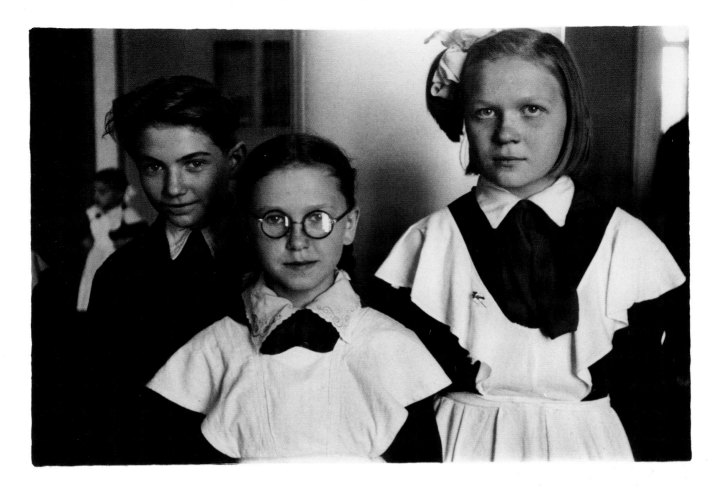

food. It was a Sunday night and I was staying at the National Hotel, which was the grand hotel in Moscow, right across the street from the Kremlin. I had been away for two weeks now, and up to this point I was euphoric and did not have time to feel homesick or lonely. Sitting in the grand dining room with its high ceiling and ubiquitous red curtains, I could see the Kremlin domes turn gold as they reflected the setting sun somewhere in Poland. Above the dome red illuminated stars were turning, and all at once I realized I was thousands of miles away from home and everything caught up with me. I felt lonely. Then I had two vodkas.

If I had never gone to Russia, and never learned to say "Могу ли я считать свою фотографию," I never would have become a photographer. I was never an amateur, I never belonged to a photo club, and I never took snapshots with my mother's Brownie. I found my bliss, that thing that Joseph Campbell had described in his Bill Moyers interviews. I was a natural, the way that some kids are naturals in sports, science, or music. It was the Tao.

Sarajevo

WHO REMEMBERS GUERNICA, LIDICE, GROZNY,
VUKOVAR, BÊN TRE, GŁOGÓW, ĐAKOVICA, PEĆ?

Sarajevo

In Sarajevo there's a mountain of meat,

Made of dead people unfit to eat,

With each hour this mountain grows higher,

And as it towers towards the sun,

It casts its shadow on everyone,

Not just those whose lives are done.

For all who cower in this grim shade,

Dread descends when daylight fades,

Now where children once played their games,

Only sad shadows remain.

Innocence soon learns there is no defense

Against its foes and our faux concerns;

When prayers fail there is no heaven, only hell.

When the savage self prevails,

Hope rots in the carcass of the city.

Why should we care with our polite pity,

Since we are here, and they are there?

OPPOSITE:
Sarajevo, 1994

SARAJEVO

In Sarajevo there's a mountain of meat, made of dead people unfit to eat,
With each hour this mountain grows higher, and it towers toward the sun,
where its shadow falls on everyone, not just those whose lives are done.
For all who cower in this grim shade, dread descends as light fades.
Now where children once played only their shadows remain.
Innocence soon learns that there is no defense against its foes and our faux concerns
When all prayers fail, there is no heaven only hell.
Where the savage self prevails, hope rots in the carcus of the city.
What good is our polite pity?
Why should we care, when we are here an they are there?

Shakespeare

My favorite poem is one written by William Shakespeare. I see him sitting in a room with a sharpened feather quill and a bottle of ink while scratching words onto stained parchment, quickly writing his thoughts before they abandon him. It is December at noon, but already the light in Stratford-upon-Avon is dimming, as everything appears as if behind a dusty scrim. The room is cold, there is a faint smell of smoke from the fireplace, a dog barks in the street below, and through the window he glimpses the church spires and the thatched roof of his theater. The whims of his muse's observations please him as he searches for a certain perfect word that eludes his meandering mind. He finds the word "Cloud-capp'd" and is satisfied with the sureness of his language. This is what he wrote on that day when poetry became music.

. . . be cheerful, sir:

Our revels now are ended. These our actors,

As I foretold you, were all spirits and

Are melted into air, into thin air:

And, like the baseless fabric of this vision,

The cloud-capp'd towers, the gorgeous palaces,

The solemn temples, the great globe itself,

Ye all which it inherit, shall dissolve

And, like this insubstantial pageant faded,

Leave not a rack behind. We are such stuff

As dreams are made on, and our little life

Is rounded with a sleep.

—THE TEMPEST, ACT IV, SCENE 1

Hedda Sterne was Saul Steinberg's wife and famously stood out as the only woman painter in the photo of abstract expressionists in *Life* magazine's 1950 feature titled "The Irascible Eighteen." Hedda lived in a brownstone on East 71st Street that she and Saul shared before their amicable divorce. I was assigned to photograph Hedda and we liked each other. She lived essentially in one large room that alternately became kitchen, living room, or studio. Often she would invite me to dinner and we chatted about everything over her Romanian goulash.

Steinberg

One evening Steinberg dropped in unexpectedly and joined our dinner conversation. Steinberg was one of the twentieth century's great philosophers, humorists, and draftsmen. That morning Art Kane, the *enfant terrible* of photography, had called me because he was doing a fashion assignment and wanted to photograph the models in the manner of a Balthus painting. With Art Kane I always felt like I was a freshman in high school, and he a senior. He came by, and I showed him all the catalogues and references I had concerning Balthus.

I told Steinberg the story of Kane's visit. Steinberg thought, and said, "An artist spends his entire life baking a cake, which is the sum total of his work. Then along comes an artist scavenger who with a swoop of his finger skims the icing off the top of the cake, a disrespectful gesture that shows no insight into the baker's genius." At that point Steinberg made a circular gesture with his index finger, and put it to his lips.

In literature one is called a plagiarist if one skims another writer's text. In the art world such trafficking is politely called appropriating, and legitimized by the establishment. It's all a matter of linguistics, but I say if it walks like a duck, and squawks like a duck, it's not Donald Duck.

OPPOSITE: *Saul Steinberg*, 1968

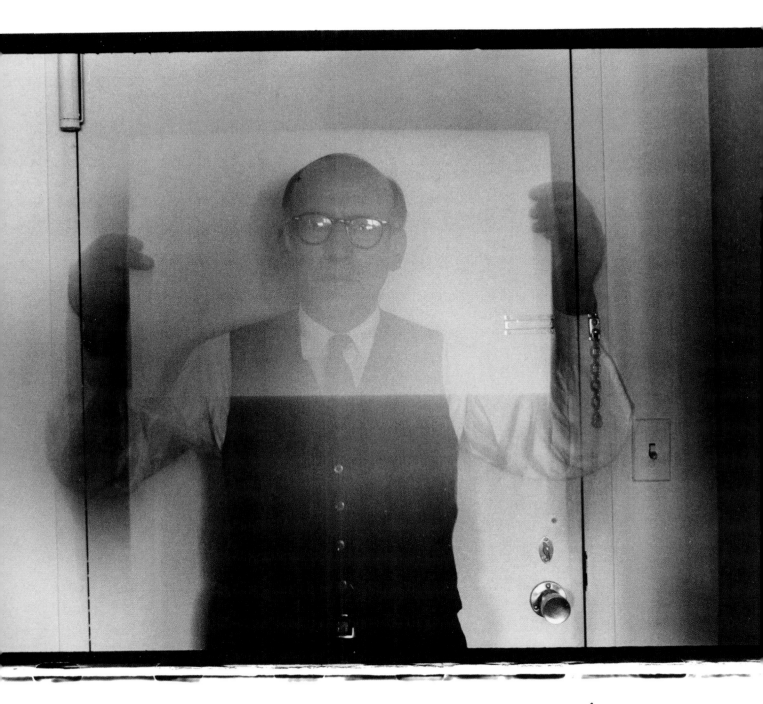

For Duane Michals
STEINBERG
Apr 68

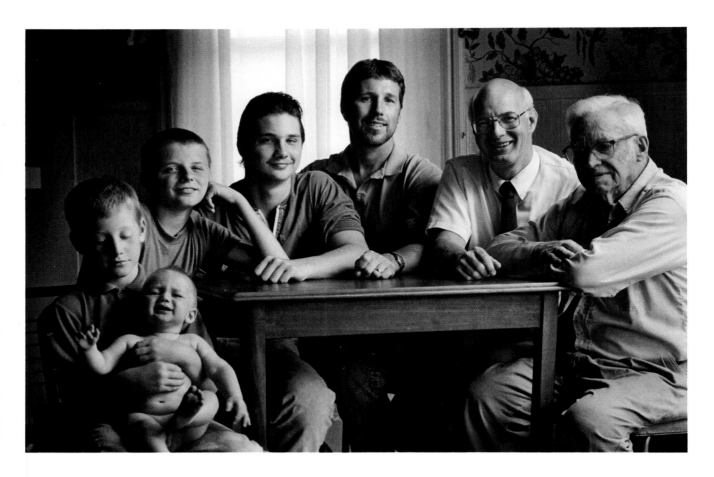

Symmetry

From life's spontaneous combustion within the cavern of the womb, there is an eloquent arc of symmetry that completes itself in the melancholy twilight of life's extinction.

The babe is bald, the grandfather's bald. The babe learns to walk, the grandfather needs a walker. The babe can't be understood, the granddad speaks gibberish. The child wets his pants and wears diapers, the old man wets his pants and wears diapers. The child recognizes his mother, the elder can't remember his mother. And so the arc ascends and descends. Birth begins with a bang and a shout, old age ends with a whisper and silence. The odyssey balances on the tip of a breath.

ABOVE: *The Seven Ages of Man*, 1994

Symmetry

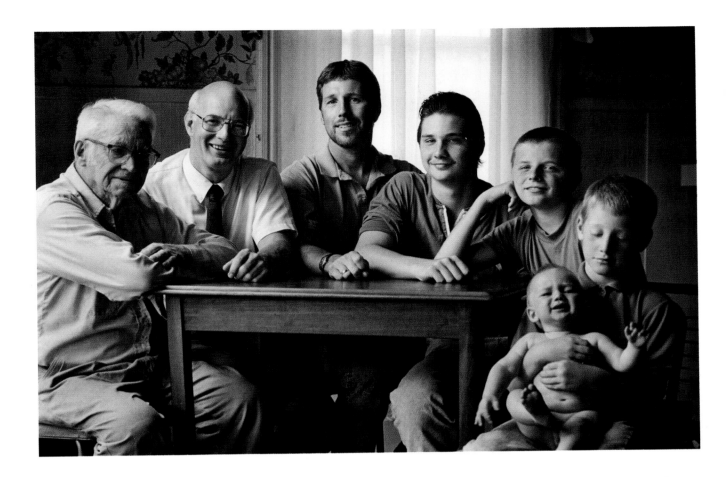

From life's spontaneous combustion within the cavern of the womb, there is an eloquent arc of symmetry that completes itself in the melancholy twilight of life's extinction.

The babe is bald, the grandfather's bald. The babe learns to walk, the grandfather needs a walker. The babe can't be understood, the granddad speaks gibberish. The child wets his pants and wears diapers, the old man wets his pants and wears diapers. The child recognizes his mother, the elder can't remember his mother. And so the arc ascends and descends. Birth begins with a bang and a shout, old age ends with a whisper and silence. The odyssey balances on the tip of a breath.

Thoreau

OPPOSITE:
Fishing Hole,
2008

One day when Henry David Thoreau was at Walden Pond a friend came to visit announcing the big news that it was now possible to send a telegram all the way from Boston to Texas. Thoreau replied, "That's amazing, but does Boston have anything to say to Texas?" Recently, as I walked from my house to the gym, which is about a block and a half, I was amused to count twenty-four people on cell phones, all jabbering away about something. Oldsters of my generation are reluctant to join the crush to constantly communicate. People on Facebook proudly announce that they have 3,000 friends, which I find appalling. It's nearly impossible to have three great

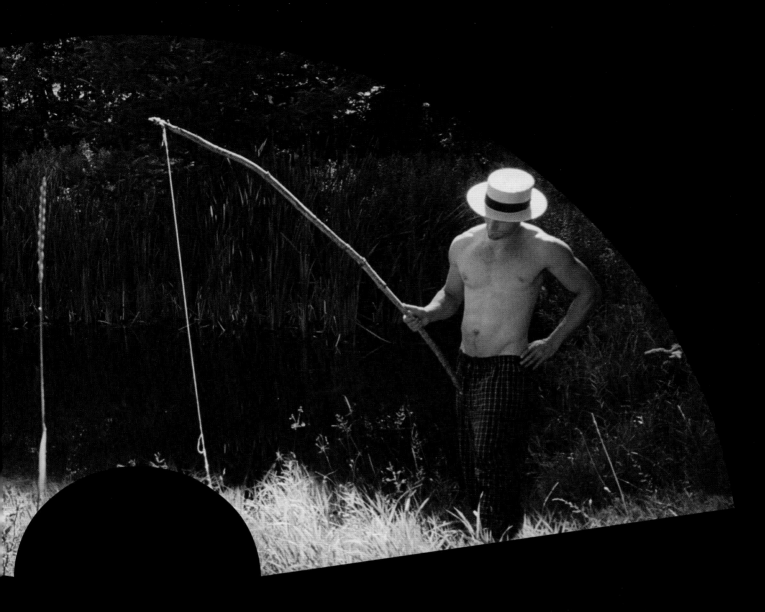

friends. Americans need to be popular and prove they exist by sharing trivia. Our culture is a caricature of a high school student's desperate need for attention. I'm sure you can remember the most popular boy and girl in your class. My McKeesport High School class had Stella Pandel and Chucky Neuswander. Americans get very upset when they realize the Somalis don't like them. "Why don't they like us? We are very nice. We send money to them, feed them, bomb them, yet their pirates try to rob us. Why don't they like us, what's wrong with us? We're pretty." And why don't they like me? Why didn't I get the Hasselblad Award, the MacArthur Fellowship, the Guggenheim grant, and *People* magazine's sexiest bald man of the year award, again?

A Modest Speculation on the Nature of the Enigma
that is the Universe (A Conundrum of Contradictions)

U*niverse*

Once upon a time there was a nothing place,

With nothing people floating in nothing space.

They thought themselves something,

But could not explain

Their appearance from nowhere

and disappearance the same.

Like water becoming ice and steam,

all sometimes waves

all sometimes strings

PAGES 164–67:
The Human Condition,
1969

Chi, Ki, Elan Vital
Talbot's Hologram
No matter how you slice it, Sam,
It's all the same.

Quick as a kaleidoscope's possibilities,
the intersection of yes and no
Stop and go
Goodbye hello.

Reality is a trompe l'oeil trick,
A sleight of hand,
Houdini's shtick.

Something is nothing turned inside out.

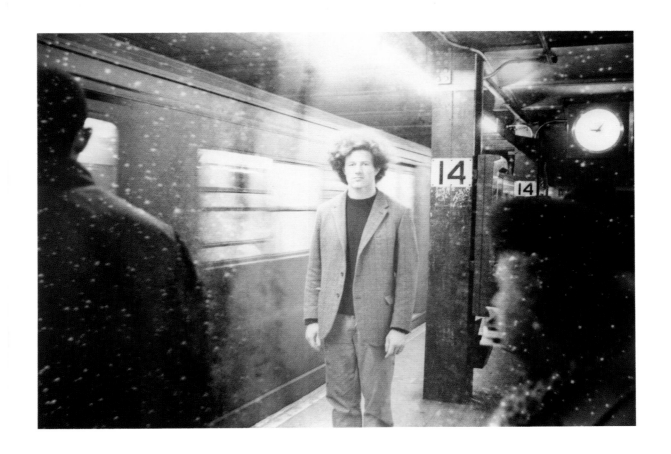

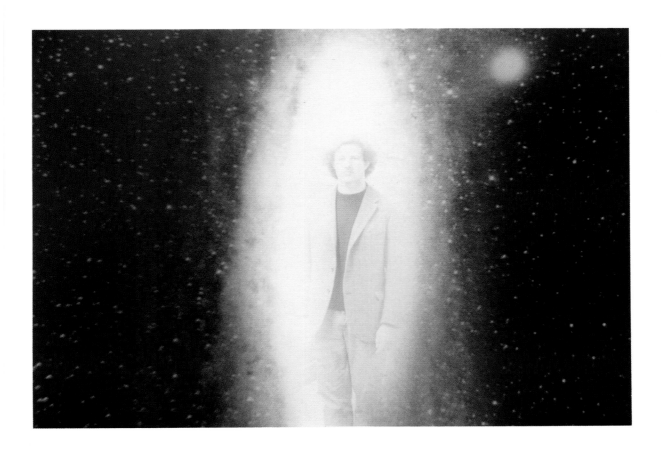

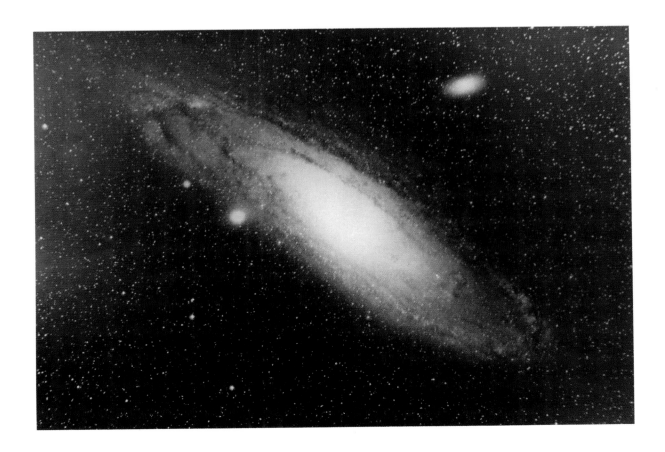

Vanishing

I can see now that I am vanishing from the strangeness of being into the strangeness of oblivion. I have vanished many times before and with each tick-tock I vanish more. Being spent, I am as translucent as my shadow. Oh the grandeur and the terror. My shade floats as if it were a cloud drifting golden in the dusk. My vertebrae crumble under the weight of my ghost, and in the mirror I can see through myself. My shadow has more substance than I do. It's my destiny; my vanity fears the worst. I hear drums, and curse my fate. I count my rings like circles in a tree, and discover I am ancient.

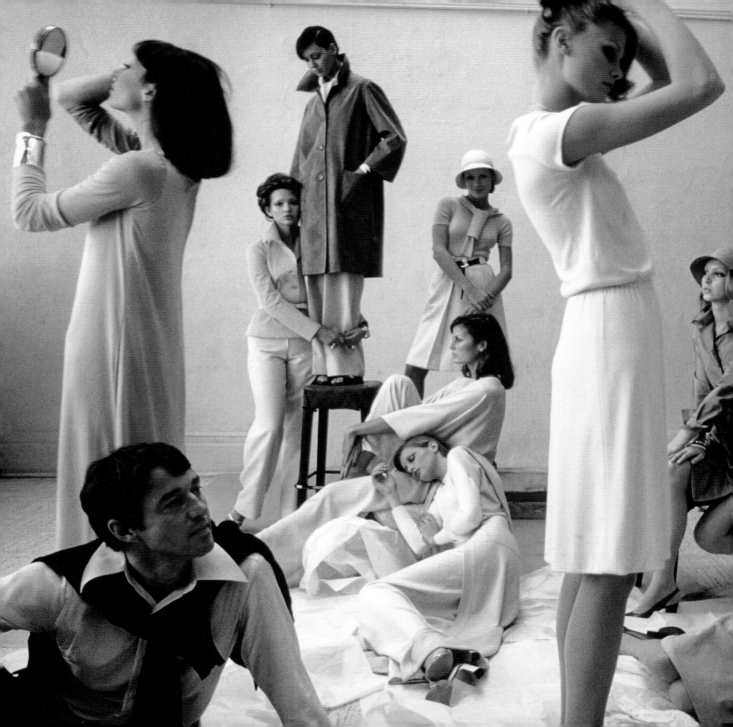

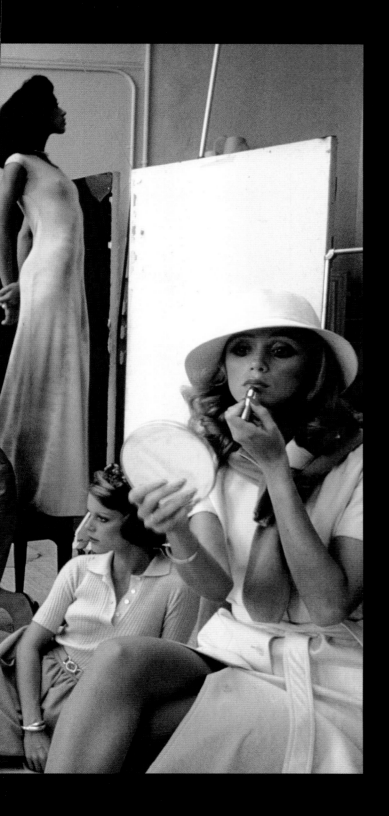

*V*ogue

Top to Bottom
(Sung to Cole Porter's "You're the Top")

You're the top!
You're an Yves A-line.
You're the top!
You're Kate Moss's behind.
You're a hip-hop song, a Lagerfeld sarong,
You're a Gabbana bonnet,
You're Hermès's comet,
You're Louis Vuitton.
Strike a pose,
Wearing Gaga's clothes,
You're a fashionista,
Evangelista.
I'm not Irving Penn or Avedon, I'm a flop,
But if, baby, I'm the bottom you're the top!

Halston and Models, 1972

V*oltaire*

Without the imprimatur

of that old fraud God,

intolerance could not exist.

Yet I find it odd

that still we are told

this is the best of all possible worlds.

Like taking Candide from babies.

———

OPPOSITE: *Voltaire*, 2013

VOLTAIRE

981, Paris Notre Dame

VOLTA

Duane
Michals

W*arhol*

Andy Warhol was a nerd. In high school he was one of those fellows who carried his books like a girl, had zits, and avoided gym; the sissy in residence. He would doodle on the back of his note pad, drawing profiles of Lana Turner and Hedy Lamarr, and he got A's in art class. His triumph as an international artistic superstar seemed very remote in the days when he went to Taylor Allderdice High in Pittsburgh. His father wanted to send Andy to Carnegie Mellon because he realized that Andy's brothers could take care of themselves in the world, but fragile Andy needed a good education to survive. Andy's is a picaresque tale. He came to New York with his friend Richard Pearlman in search of the rewards of the city: fame, sex, and money.

When I met Andy he had developed a style, a blotchy line technique that was immediately recognizable and had a chic well suited to fashion illustration. My friend

THIS PAGE & OPPOSITE:
Andy Warhol, 1980

Tom Lacy was working with Andy at Bonwit Teller as a layout artist for newspaper advertising. He mentioned that Andy Warhol was from Pittsburgh, and wanted us to meet.

It was kismet.

We had so much in common, coming from a similar background. We were both blue-collar kids, with a Slovak immigrant heritage and artistic inclinations. Talking to Andy on the phone was like talking to a telephone off the hook.

Ring, ring.

"Hello."

"Dah dah dah dah dah. Hello Duane. Dah dah dah dah dah."

"Hi Andy."

"Dah dah dah dah dah dah. What's new, Duane?"

"I saw your I. Miller shoe ads. Andy, they were beautiful."

"Dah dah dah dah dah dah. Thanks Duane. Dah dah dah dah. Duane you're fabulous. Dah dah dah dah dah. Can you come to lunch at noon tomorrow? Dah dah dah dah dah."

"I'll see you then."

"Dah dah dah dah. So long, Duane."

"So long, Andy."

When I arrived at Andy's for lunch at noon the next day, he opened the refrigerator and all it contained was a bottle of Chivas Regal and a salami.

Under the sweltering hospital tents the heat from the scorching Potomac sun rested like blankets on wounded soldiers of the Northern Army. The flies made a buzzing sound as they were shooed away from bloody bandages by the nurses. The water they ladled from buckets for the perspiring men was warm and did not relieve their thirst. In one corner a recently amputated soldier could not cry anymore, exhausted by the pain. The healthier men spent their time rereading letters from home. One played the only tune he knew on his harmonica over and over. Corporal Stanton died after a week of horror. His bunk was immediately reoccupied by a redheaded fellow who could not remember his own name. It was August 12, 1864.

As the endless war continued to drown the new democracy in the blood of its youth, Washington hosted a number of army hospitals: The Armory Square Hospital, Campbell Hospital, Finley Hospital, and Harewood Hospital. Every Sunday afternoon a middle-aged man, who looked much older because of his white beard, could be seen wandering through the tents carrying notepaper, candy, sometimes flowers, as he visited the lonely, fevered soldiers. He would stop and sit beside a sleeping private, hold his hand, then move on, leaving a rose on his chest like a calling card. At a distance you could see the old man cry as he leaned forward to hear a whispered confession, as if he were a priest.

Once the visitor saw a recently freed black slave from Georgia, who had fought for the North. Nobody bothered to speak to him, and blood from his wound had not been cleaned. The old man stopped and chatted with him. He inquired, "Are you married, where are your parents, can I get you something to eat?" For the length of the sentences, Corporal Sam felt almost happy.

The old man was Walt Whitman. On his days off from the Bureau of Indian Affairs, he would take the trolley to the end of the line, then walk through the fields to his destination: the army infirmaries. It was his natural instinct to play the part of the amateur nurse. He could be their companion, confessor, father, brother, lover, taking care to comfort the wounded boys. The fallen men felt love for the stranger. Many of them would die, many would leave for home limping, others could not see the man who washed their faces with a damp cloth, but all would remember him.

OPPOSITE:
John as Union Soldier,
1996

Some specimen cases – June 18th – In one of the hospitals I find Thomas Haley, Company M, 4th New-York cavalry – a regular Irish boy, a fine specimen of youthful physical manliness. shot through the lung – inevitably dying – came over this country from Ireland to enlist –
has not a single friend or acquaintance here – is sleeping soundly at this moment
(but it is the sleep of death) has a bullet-hole straight through the lung.
Little he knew, poor death-stricken boy, the heart of the stranger that hovered near.
Walt Whitman

In Xanadu
on X-Mas day
the X-Man
filmed an XXX-rated extravaganza
entitled *X marks the G-spot*
in excelsis mayo.

ABOVE:
Ex-Lax, 2014

Wet Dream

I dreamt last night I proposed,
To a girl who was wearing no clothes.
In her garden for hours,
I watered her flowers,
And awoke with a drip from my hose.

Youghiogheny

On the banks where the mighty Monongahela and Youghiogheny rivers marry, Queen Aliquippa met with George Washington when he was a surveyor for the colonies. The same site was the spot where General Braddock encamped before pushing north to Fort Pitt. He was ambushed by the French and Indians and routed at the site of present-day Turtle Creek. In 1795, after coal was discovered in the area, the site was settled by John McKee, and it became a village in 1830. By 1872, McKeesport had become a thriving city, and the National Tube Company was located there. Eventually it employed ten thousand workers. The city fell on hard times with the demise of the steel industry and is now a shadow of its former self.

I was born in McKeesport, and graduated from McKeesport High School in 1949. I remember it as being a perfect place to grow up, despite the fact my father worked in the steel mill across the river in Duquesne, and my family had no social credentials that would aid upward mobility. During the Second World War, I was convinced that Hitler would send squadrons of Stuka dive bombers to obliterate the city because it was the ideal seat of all things democratic and quintessentially American. Luckily they did not show up. I liked McKeesport and I still do.

The Youghiogheny River was particularly foul when I lived there. The aptly named Water Street seemed to be flooded every other year with nasty debris. The river itself was a curious shade of orange-brown with its chemicals and waste rushing downstream to mix with the even more filthy Monongahela. Some of the hardier high school boys would swim across the Monongahela and back as a rite of passage. I was never part of the gang who performed such feats of derring-do. They proved their manhood with this act of bravery. They were heroes to me, capable of doing things I couldn't, and I admired them. I did not swim well, and the thought of navigating my body through the swill was daunting. What brave foolishness, yet they survived. My different sort of foolhardiness emerged later.

OPPOSITE: *Youghiogheny River*, 1982

Zero

Zero plus zero equals zero.
Zero from zero equals zero.
Zero times zero equals zero.
Therefore it follows that Zero Mostel
minus the Mostel equals zero,
who therefore does not exist.

THIS PAGE & OPPOSITE:
John Draws Nothing, 1991

The Duane Michals Collection *at* Carnegie Museum of Art

The following are gifts or partial gifts to the museum, as of spring 2014.

Works reproduced in this publication are indicated with an asterisk (*)

Berenice Abbott*
Portrait of Eugène Atget, 1927
Gelatin silver print
13 × 10 in. (33 × 25.4 cm)

Eugène Atget*
Flower Shop (Boutique fleurs), 1925
Gelatin silver print
13 × 10 in. (33 × 25.4 cm)

Eugène Atget
La Villette, rue Asselin, Prostitute Looking for Clients in Front of Her Door (La Villette, rue Asselin, fille publique faisant le quart devant sa porte), 1921
Gelatin silver print
13 × 10 in. (33 × 25.4 cm)

Balthus
Study for *Nude with a Chair*, 1957
Pencil on paper
20½ × 16 in. (52.1 × 40.6 cm)

Balthus
Untitled (Head of a Woman), mid-20th century
Pencil on paper
8¾ × 12 in. (22.2 × 30.5 cm)

Balthus*
Study for *The Mediterranean Cat*, 1949
Pencil on paper
5⅞ × 7½ in. (14.9 × 19.1 cm)
Photo: Jeffrey Sturges

Balthus*
Study for *Passage du Commerce-Saint-André*, 1952–54
Pencil on graph paper
6¼ × 7½ in. (15.9 × 19.1 cm)
Photo: Jeffrey Sturges

Georges Braque*
Fox, 1911–12
Drypoint on ivory laid paper
25⁵⁄₁₆ × 19³⁄₁₆ in. (64.3 × 48.7 cm)
© 2014 Artists Rights Society (ARS), New York / ADAGP, Paris

Giorgio de Chirico*
Study for *The Anxious Journey*, 1913
Pen and ink on paper
8¹¹⁄₁₆ × 6 in. (22.1 × 15.2 cm)
© 2014 Artists Rights Society (ARS), New York / SIAE Rome
Photo: Jeffrey Sturges

Chuck Close
James, 2004
Screenprint on paper
61 × 48 in. (154.9 × 121.9 cm)

Joseph Cornell*
Untitled, 1971
Three-part collage; gelatin silver prints with mixed media
9 × 12 in. (22.9 × 30.5 cm) each
© The Joseph and Robert Cornell Memorial Foundation / Licensed by VAGA, New York, NY

Honoré Daumier
Robert Macaire, Wholesaler (Robert Macaire, Négociant), from the series *Caricaturana* (no. 27), 1838
Lithograph with hand coloring on paper
13⅛ × 10¼ in. (33.3 × 26 cm)

Honoré Daumier
My Dear Stockholders (Messieurs les actionnaires), from the series *Caricaturana* (no. 31), 1838
Lithograph with hand coloring on paper
10¼ × 13 in. (26 × 33 cm)

Honoré Daumier
Robert Macaire, Merchant of Bibles (Robert Macaire, Md. de Bibles), from the series *Caricaturana* (no. 89), 1838
Lithograph with hand coloring on paper
13⅛ × 10¼ in. (33.3 × 26 cm)

Honoré Daumier
Triumph of Political, Commercial and Literary, etc., Integrity (Triomphe de la probité politique, commerciale, littéraire etc. etc.), from the series *Caricaturana* (no. 94), 1838
Lithograph with hand coloring on paper
10¼ × 13 in. (26 × 33 cm)

Honoré Daumier
Yes Sir, in exchange for a small subscription with our insurance . . . (Oui, Monsieur, moyennant un petit abonnement à notre assurance . . .), from the series *Caricaturana* (Number 95), 1838
Lithograph with hand coloring on paper
13 × 10¼ in. (33 × 26 cm)

Jared French*
Paul Cadmus, c. 1940
Gelatin silver print
9⁷⁄₁₆ × 6¹¹⁄₁₆ in. (24 × 17 cm)

Lucian Freud*
Large Head, 1993
Etching on paper
32½ × 26⅛ in. (82.6 × 66.4 cm)
© The Lucian Freud Archive / The Bridgeman Art Library
Photo: Jeffrey Sturges

Paul Gauguin
Women at the River (Auti te Pape), from the series *Fragrance (Noa Noa)*, 1893–94
Color woodcut printed in 18 sections on heavy Japanese paper
9⅞ × 15¾ in. (25.1 × 40 cm)

Francisco de Goya
Pretty Teacher! (Linda maestra!), from the series *Los Caprichos* (no. 68), c. 1799
Etching with aquatint
8¼ × 6 in. (20.96 × 15.24 cm)

Lewis Wickes Hine*
Two Seven-Year-Old Nashville Newsies, Profane and Smart, Selling Sunday, 1910
Gelatin silver print
5 × 7 in. (12.7 × 17.8 cm)

David Hockney
Henry Geldzahler, 1977
Pen and ink on paper
14 × 11 in. (35.6 × 27.9 cm)

David Hockney*
Soft Celia, 1998
Soft-ground etching on paper
43¼ × 30¼ in. (109.9 × 76.8 cm)
© David Hockney. Photo: Jeffrey Sturges

David Hockney*
Henry Seated with Tulips, 1976
Color lithograph
42 × 30 in. (106.7 × 76.2 cm)
© David Hockney / Gemini G.E.L.
Photo: Richard Schmidt

Horst P. Horst
Self-Portrait with Gertrude Stein, 1946
Gelatin silver print
14 × 11 in. (35.6 × 27.9 cm)

André Kertész
The Fork, 1928
Gelatin silver print
3¼ × 4⁷⁄₁₆ in. (8.3 × 11.3 cm)

André Kertész
Colette, 1930
Gelatin silver print
3¼ × 4⁷⁄₁₆ in. (8.3 × 11.3 cm)

André Kertész
Distortion #40, 1933
Gelatin silver print
3¼ × 4⁷⁄₁₆ in. (8.3 × 11.3 cm)

Paul Klee
Ilse, 1926
India ink on paper
12¼ × 9¾ in. (31.1 × 24.8 cm)

Edward Lear*
Dumpling, Dumpling Dee/The Fish Hopped Out of the Sea/The Little Pig Cried, When the Grasshopper Died/and the Crow Flew Away with the Bee, c. 1845
Brown ink on 3 sheets of J. Whatman paper
5⅞ × 8⅞ in. (14.9 × 22.5 cm)
Photo: Jeffrey Sturges

Herbert List
Sand and Large Pins, 1933
Gelatin silver print
8½ × 11½ in. (21.6 × 29.2 cm)

Herbert List*
The Monument to King Constantine of Greece, Shortly Before Its Unveiling, 1937
Gelatin silver print
12 × 9½ in. (30.5 × 24.1 cm)
© Herbert List / Magnum Photos

George Platt Lynes
Paul Cadmus, Jared French, and George Tooker, c. 1945
Gelatin silver print
9⁷⁄₁₆ × 6¹¹⁄₁₆ in. (24 × 17 cm)

René Magritte
A Rose in the Universe (Une rose dans l'univers), 1961
Red pencil on paper
12 × 9 in. (30.5 × 22.9 cm)

René Magritte*
The Indiscreet Jewels (Les bijoux indiscrets), 1963
Color lithograph on paper
9¼ × 12 in. (23.5 × 30.5 cm)
© C. Herscovici / Artists Rights Society (ARS), New York. Photo: Jeffrey Sturges

Édouard Manet
Lola de Valence, 1863
Etching with aquatint and engraving on paper
10¾ × 7¼ in. (27.3 × 18.4 cm)

Louis Marcoussis
Portrait de Miró, 1938
Etching, engraving, and drypoint on paper
19⁵⁄₁₆ × 15 in. (49.1 × 38.1 cm)

Giorgio Morandi
Still Life with White Objects on a Dark Background (Natura morta con oggetti bianchi su fondo scuro), 1931
Etching on paper
9½ × 11½ in. (24.1 × 29.2 cm)
© 2014 Artists Rights Society (ARS), New York / SIAE Rome
Photo: Jeffrey Sturges

Joan Nelson
Untitled, 1987
Oil on panel
19 × 22 in. (48.3 × 55.9 cm)

Irving Penn
Fritz Gruber, 1955
Gelatin silver print
8 × 8 in. (20.3 × 20.3 cm)

Irving Penn
Balthus, Paris, 1948
Gelatin silver print
15 × 18½ in. (38.1 × 47 cm)

Guglielmo von Plüschow
Male Nude, c. 1880
Gelatin silver print
6½ × 8½ in. (16.5 × 21.6 cm)

Odilon Redon
Tree (Arbre), 1892
Lithograph on chine appliqué
18¾ × 12⅜ in. (47.6 × 32 cm)

Saul Steinberg
Le Négri, 1968
Pen and ink on paper
16 × 20¼ in. (40.6 × 51.4 cm)

Mark Tansey
Lens, 1999
Oil on canvas
69 × 48 in. (175.3 × 121.9 cm)

Henri Marie Raymond de Toulouse-Lautrec
Madame Réjane, 1898
Lithograph on paper
11⅗ × 9½ in. (29.5 × 24.1 cm)

Félix Vallotton
The Patriotic Ditty (Le couplet patriotique), 1893
Woodcut on paper
7 × 8¾ in. (17.8 × 22.2 cm)

Félix Vallotton
The Gust of Wind (Le coup de vent), 1894
Woodcut on paper
7 × 8¾ in. (17.8 × 22.2 cm)

ADDITIONAL ILLUSTRATION:

Robert Qualters
Edward Hopper Was Driving, 1997
Screenprint
24 × 32 in. (61 × 81.3 cm)
Collection of the artist